IMAGES
of America

COHASSET

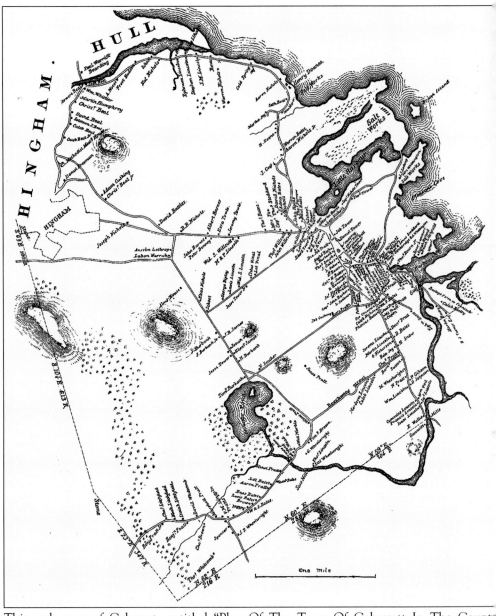

This early map of Cohasset, entitled "Plan Of The Town Of Cohassett In The County Of Norfolk," was printed by Bouve & Sharp, located at 221 Washington Street, Boston, c. 1843–45.

IMAGES
of America

COHASSET

David Wadsworth, Paula Morse,
and Lynne DeGiacomo
for the Cohasset Historical Society

ARCADIA
PUBLISHING

Published by Arcadia Publishing
Charleston, South Carolina

Printed in the United States of America

Library of Congress Catalog Card Number: 2003111665

For all general information contact Arcadia Publishing at:
Telephone 843-853-2070
Fax 843-853-0044
E-mail sales@arcadiapublishing.com
For customer service and orders:
Toll-Free 1-888-313-2665

Visit us on the Internet at www.arcadiapublishing.com

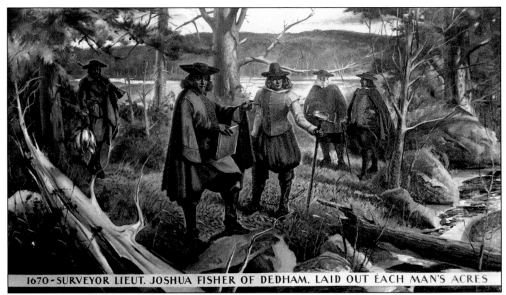

1670-SURVEYOR LIEUT. JOSHUA FISHER OF DEDHAM, LAID OUT EACH MAN'S ACRES

In 1670, Lt. Joshua Fisher surveyed the unpopulated uplands of Hingham's Conahasset and divided them into shares for conveyance to qualified landowners. Soon the first farms and homesteads were established, and the area's name was shortened to Cohasset. MacIvor Reddie painted this and three other scenes depicting Cohasset history in 1947 for the rotunda of the Paul Pratt Memorial Library.

CONTENTS

ACKNOWLEDGMENTS

We wish to first thank Kathy O'Malley, the Cohasset Historical Society's remarkably even-tempered and resourceful co-president, who shared with us the task of gathering the photographs, while assuming many of our responsibilities as the deadlines got closer; Tom Gruber, the society's first vice president, who gave freely of his computer expertise at a moment's notice; and Marilyn Morrison, who assisted with proofreading and manuscript preparation. They are quickly followed by our appreciation of Lynne's family—Mark, Jim, and Sam DeGiacomo—who gave up countless hours of quality time with Lynne for the sake of this book. We also wish to acknowledge the board of directors of the Cohasset Historical Society and its support of this project during a period of great change that included our move to new headquarters at the Pratt Building.

We also want to thank the following who loaned photographs and/or shared their understanding of Cohasset's past: Rebecca Bates-McArthur, John Connell, Joanne Ford, Debra Krupczak, Valerie Lipsett, Helen and William Luscombe, Ann Montague, Edward Mulvey, Dee Dee Perry, Barbara Power, Mary Quill, Alexander Rose, Carol St. Pierre, Rich Silvia, Philip Smith, the Snowdale family, Anne and Gary Vanderweil, Tina and James Watson, and Frank White.

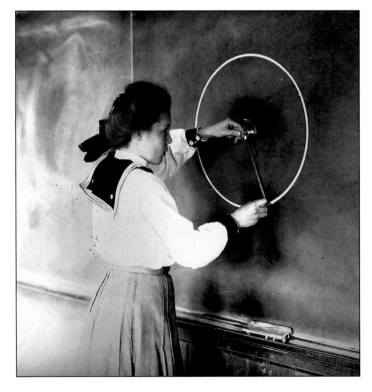

Dorothy Nichols, the mother of coauthor David Wadsworth, demonstrates a blackboard compass invented by Stanley Lary, principal of the Osgood School, where she was a student when this c. 1908 photograph was taken.

INTRODUCTION

While the history of Cohasset, from its geological beginnings to the present day, has been well documented by the Committee on Town History, there has been no similar pictorial history. Now, thanks to the opportunity afforded by Arcadia's Images of America series, we have begun to fill that gap. This book covers Cohasset from c. 1850 to 1950, its images drawn from the Cohasset Historical Society's archives and loans from Cohasset residents.

The name Cohasset comes from the Native American word *Quonohasset*, which means "long rocky place." When Hingham was founded in 1635, its eastern section was called Conahasset, which included a rocky shoreline with meadows where salt hay was harvested. The first farms and homesteads were built shortly after 1670, and by 1700, small shipyards could be found at Ship Cove, today's Cohasset Harbor. In 1717, Cohasset (by then, the extra syllable had been dropped) became Hingham's Second Precinct, allowing residents to hire their own clergyman and teacher and build their first meetinghouse and schoolhouse. After years of debate about whether to separate from Hingham, Cohasset was incorporated on April 26, 1770.

After the War of 1812, shipbuilding and mackerel fishing expanded, with Cohasset ship owners participating in the great age of sail. The extension of the railroad line through town in 1849 created more social and economic opportunities for residents. By mid-century, Portuguese, Irish, and Italian families had begun settling here. During the 1870s, at a time when the maritime industry was on the decline, Cohasset's scenic beauty and cool ocean breezes were discovered by theater personalities and wealthy Bostonians who began summering here and building large estates. Pleasure yachts soon replaced fishing schooners in the harbor.

In the early years of the 20th century, Cohasset benefited from forward-thinking individuals who formed associations to acquire large tracts of land for public recreation and conservation. The 1930s and 1940s saw summer homes being transformed to year-round residences by owners seeking relief from Boston's high tax rates. By the 1950s, Cohasset had become increasingly suburban, with many residents commuting to Boston.

Many of the qualities that shine in this book remain part of the town's character. We are never far from the sea or the many coves and inlets that brush against marsh and ledge. Along with the many stately Colonial homes that survive, a fine sampling of the great Victorian cottages remains along the shore roads, as do those more modest homes around the harbor that were once owned by ship captains and local fishermen. However, what makes Cohasset truly special has always been its people, whose love for the town is evident whether they are walking through Whitney Woods, sailing in the harbor, or debating at town meeting.

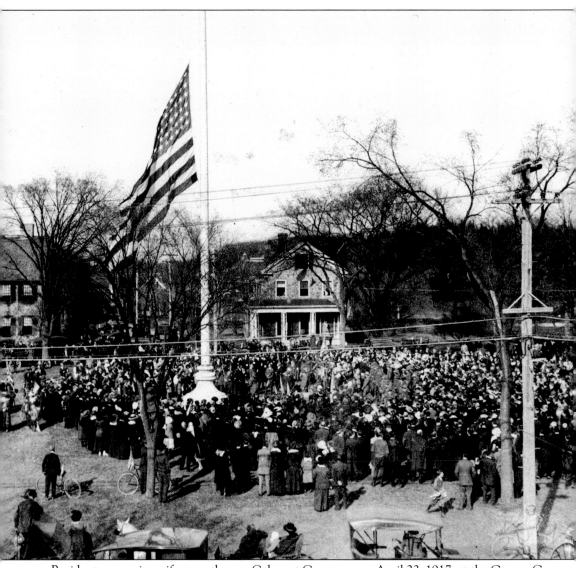

Residents, many in uniform, gather on Cohasset Common, on April 22, 1917, at the George G. Crocker memorial town flagpole, given by members of the Crocker family in 1915.

One

AROUND THE COMMON

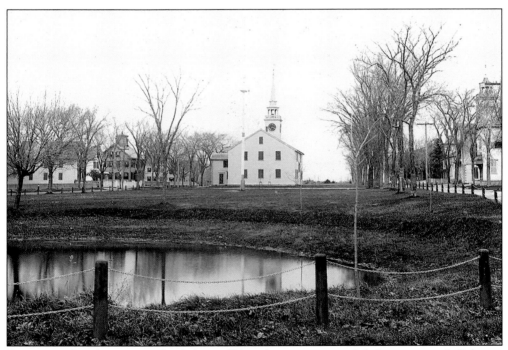

Ever since Conahasset was divided in 1670 and a portion was left "in common," Cohasset Common has been the aesthetic centerpiece of this quintessential New England town. While greatly reduced in size through land grants and encroachments by residents, today's Cohasset Common seems destined to remain unchanged. Over the years, it has been the site of the first schoolhouse, the first seat of government and religion, the first municipal flagpole, and the town's whipping post and stocks. Cohasset Common and the surrounding houses and public buildings, among the earliest in town, form a historic district listed in the National Register of Historic Places since 1996. The chain fence in this photograph from the 1880s was intended to keep animals off the common, not on it.

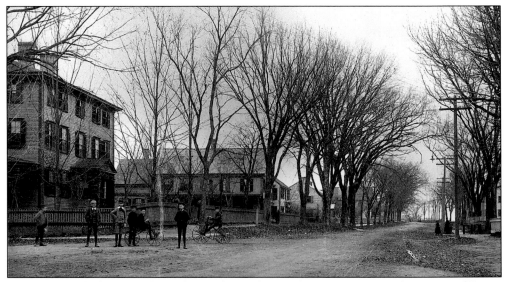

Youngsters with their bicycles gather in front of 3 North Main Street, at the corner of Depot Court. Today's South Shore Community Center, the 1750 Deacon Elisha Doane house was a doctor's office and residence in the early 1900s, when this photograph was taken. The house was saved for community use in 1938 through the efforts of the Cohasset Improvement Association led by Edwin Furber.

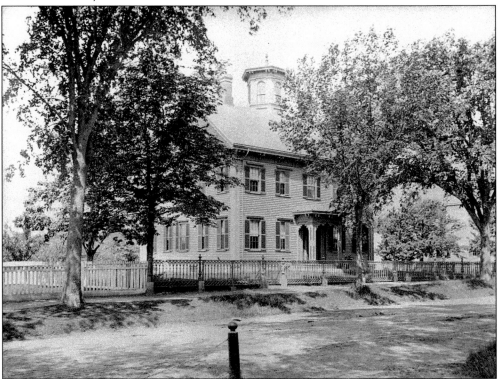

Ship owner and captain Joseph H. Smith (1817–1879) built this Italianate-style house at 35 North Main Street in 1858 on the site of an earlier cottage that was moved to Elm Street in the 1850s. The large cupola was removed in 1940, and a porch was added.

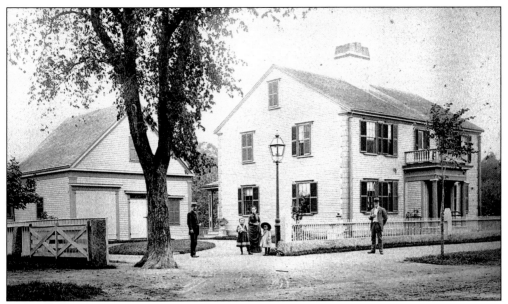

In this 1880s photograph, Edmund and Mary Tower Osgood and their two children stand with Mary's father, Abraham Tower, next to his grandfather's 1802 Federal-style home (now 45 North Main Street). Capt. Abraham Tower (1752–1832) took part in the Boston Tea Party, and after the Revolution, started the family fishing and lumber business at the harbor.

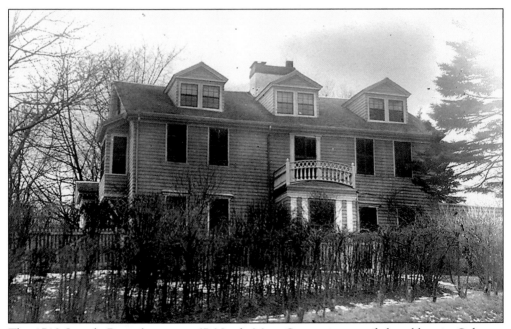

The 1713 Joseph Bates house, at 67 North Main Street, is one of the oldest in Cohasset and retains its original enclosed vestibule with segmental arch pediment and a stout, center-ridge chimney. An early Conahasset settler, Joseph Bates (1660–1713) never lived in the mansion-house he built, but his son Joseph did until his death in 1750.

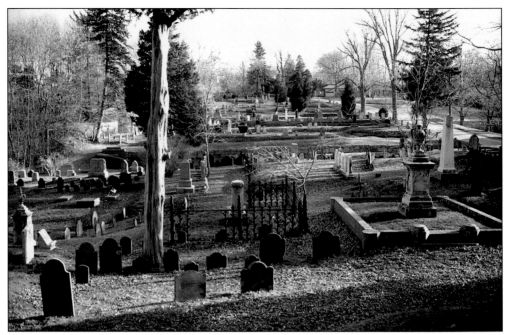

Cohasset Central Cemetery, listed in the National Register of Historic Places in 2002, is the town's oldest burying ground, with a grave dating from 1705. From Puritan slate markers to Victorian marble and modern granite tombstones, the cemetery reflects the history of Cohasset, and many of the people featured in this publication are buried here. (Courtesy Cohasset Central Cemetery.)

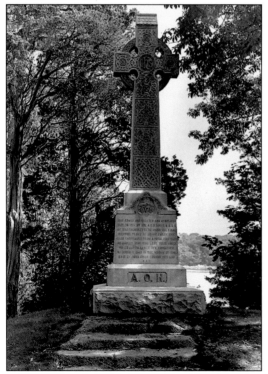

On October 6, 1849, the Irish brig *St. John,* a famine ship from Galway, encountered a severe ocean storm and struck the Grampuses Ledge near Minot's Ledge Lighthouse. In vain, the crew cut away masts and rigging in an attempt to lighten the vessel, but within an hour she was totally destroyed. Ninety-nine passengers and crew perished, and only twenty-three reached shore safely. About forty-five of the deceased were never identified, and they were buried in a mass grave in Cohasset Central Cemetery. On May 31, 1914, the Ancient Order of Hibernians and their auxiliary placed a twenty-foot granite Celtic cross on the highest hill near the grave to commemorate the event.

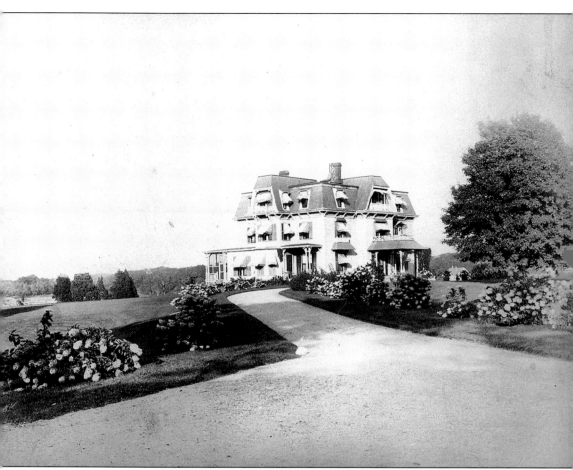

Charles Bates (1818–1904) lived in this Second Empire house at 82 North Main Street on Little Harbor. He was the principal benefactor for the purchase of land for the first Osgood School on Elm Street. In 1923, Edwin Furber, who owned the Federal-style house across the street at the corner of Sohier Street, bought the Bates House and tore it down because his view of the ocean was blocked by this sizable mansion.

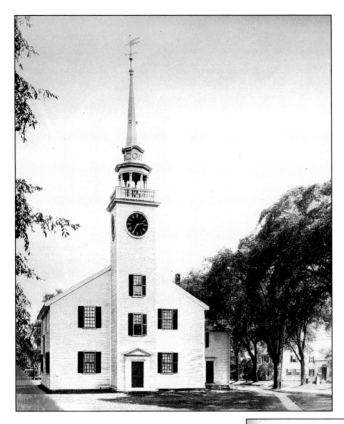

The 1747 Meeting House on Cohasset Common was the seat of precinct and town government, as well as the center of religious life, and became the First Parish Church in 1770, when Cohasset separated from Hingham. Its original simple design was enhanced by the addition in 1799 of a square north tower and octagonal steeple. In 1825, the town surrendered its responsibility toward public worship and management of the church was left to the pew owners.

Rev. Joseph Osgood (1815–1898), minister of the First Parish Church from 1842 to 1895, began his tenure while the community was still bitter over the secession of some members during the great Protestant schism. He is attributed in large part with healing the animosity. Immensely popular, he served on the school committee for 25 years and then became superintendent of schools from 1873 to 1885. Reverend Osgood was also chairman of the Committee on Town History, which produced *A Narrative History of the Town of Cohasset, Massachusetts* in 1898. At a town meeting in 1961, voters honored his contributions, making sure that "there will always be in this Town a school named Osgood School."

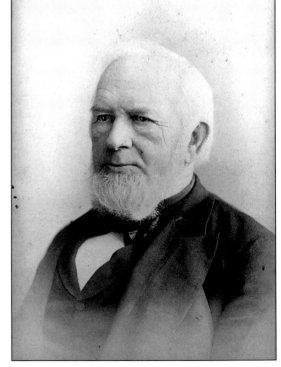

The Second Congregational Church on Highland Avenue was founded by First Parish Church members dissatisfied with the Unitarian movement. On land given by Capt. Nichols Tower in 1824, the church was constructed as a one-story structure and then in 1878, elevated and remodeled in a Gothic Revival style, as shown in this photograph. After a fire in 1927, the church was repaired and altered to its present Colonial Revival appearance. (Courtesy Second Congregational Church.)

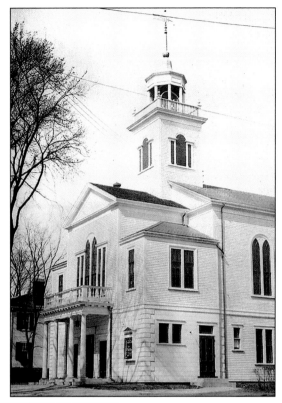

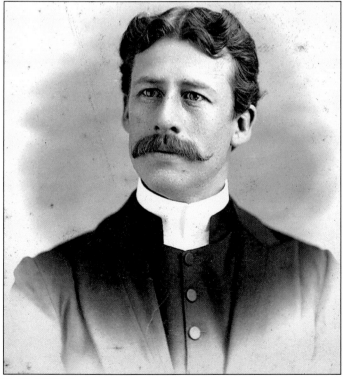

Minister of the Second Congregational Church from 1891 to 1901, Rev. E. Victor Bigelow (1866–1929) was the author of the monumental *A Narrative History of Cohasset*, which chronicled the town's history from its geological origins to the end of the 19th century.

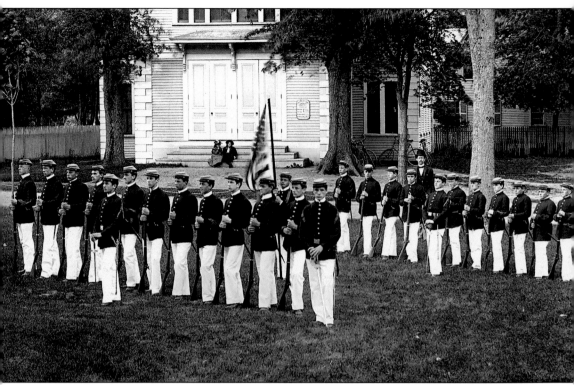

The Endeavor Cadets assemble in front of the Second Congregational Church on July 7, 1898, with their drillmaster and founder, Rev. E. Victor Bigelow. Open to boys in town from age 12 to 16, the Endeavor Cadets drilled with Civil War rifles having wooden barrels. Funds earned from dances and exhibition drills helped them to buy their rifles, bayonets, scabbards, and blue-and-white uniforms. Encampments were held at Whitehead for a day or two in the summer. The cadets, one of the earliest attempts at organized recreation for young people in Cohasset, lasted only a few years.

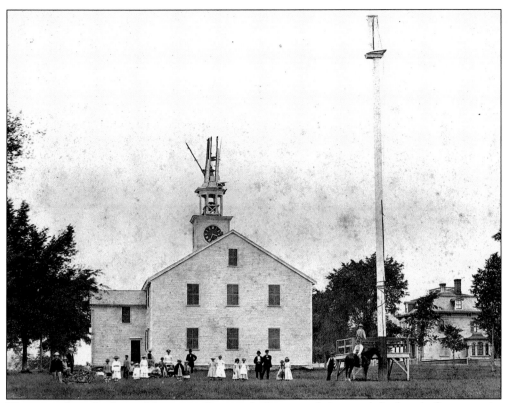

The town flagpole, located between the meetinghouse and the pond, had a platform near its base that was used as a bandstand. Farther away the meetinghouse sits, shutters closed, after the lightning strike of July 1869 nearly demolished the steeple.

Town hall is shown here in 1926 before it was remodeled for about $40,000. Now the town parking lot, Frank Browne's house on the right was taken by eminent domain in March 1926, after the town voted to build a new town hall. However, these plans were abandoned in 1927.

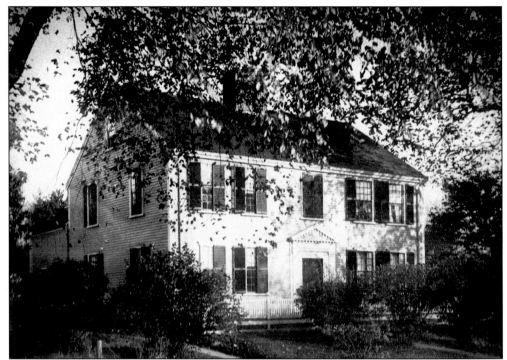

Rev. Josiah Crocker Shaw, minister of the First Parish Church from 1792 to 1796, built this Georgian-style house (now 23–25 Highland Avenue) in 1794. The house features two original door surrounds with projecting triangular pediments lined with dentils. (Courtesy Alexander Rose.)

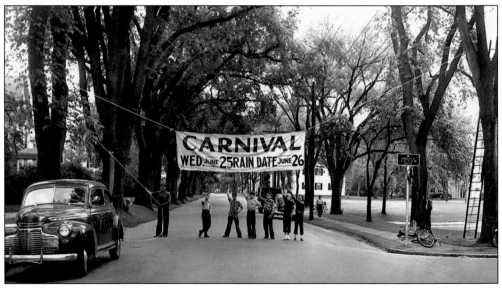

The Cohasset Carnival, held in late June, was a high point of summer activities from 1934 until the 1950s. Sponsored by the three churches around Cohasset Common, the carnival had attractions for all ages. Other organized events have included church fairs, art festivals, dog-training classes, and summer band concerts, whereas informal activities range from touch football and soccer to Frisbee and racing model boats in the pond.

St. Stephen's Episcopal Church, completed in 1900, sits atop the ledge overlooking Cohasset's center village. This granite Gothic Revival church was designed by Cram, Goodhue, & Ferguson, well-known Boston architects, and built by Cohasset resident Lyman D. Willcutt. The main entrance is approached by a steep flight of stairs built into the granite ledge.

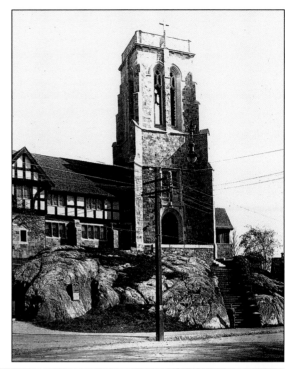

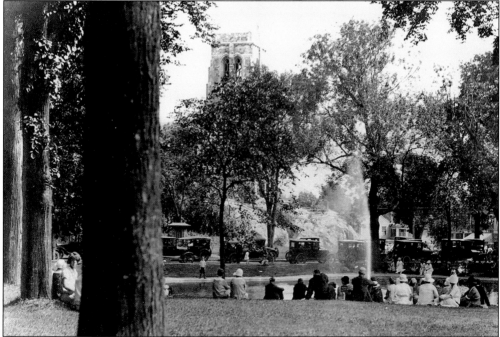

St. Stephen's bell tower was built in 1906, and the original 23 bells cast in England were installed in 1924. Additional bells were added in later years to make up the 57-bell carillon, considered one of the finest in the world. The line of parked automobiles helps to date this photograph from the 1920s. Recitals on Cohasset Common continue to attract music lovers from afar.

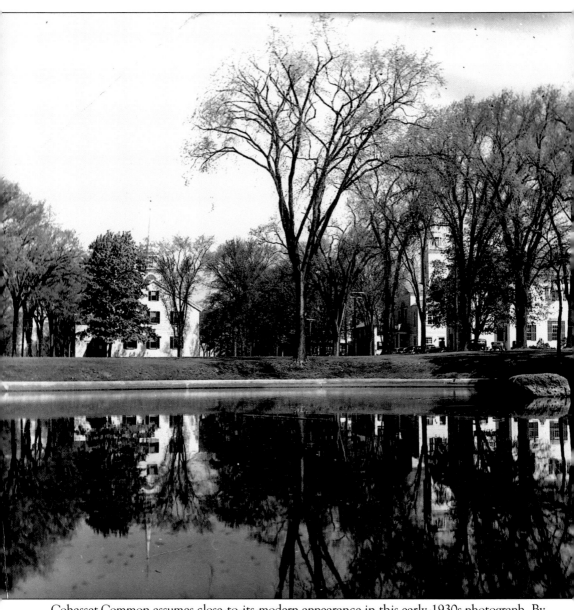

Cohasset Common assumes close-to-its-modern appearance in this early-1930s photograph. By this time, the Second Congregational Church and town hall were remodeled, but the towering American elms still gracefully frame the perimeter. Walkways and a concrete wall for the pond had been introduced c. 1903, and the rock with its fountain had been placed in the middle of the pond even earlier.

Two

THREE VILLAGES

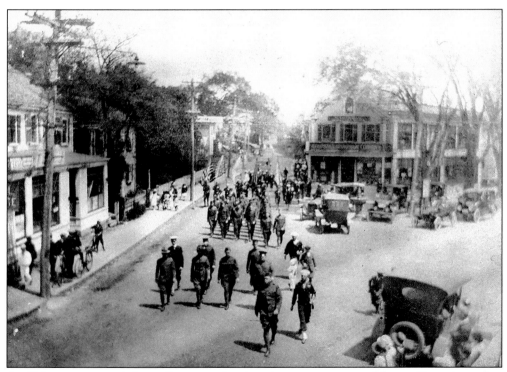

As Cohasset was settled, small centers developed to serve groups of farms. Over time, they became three distinct villages—today's center village, Jerusalem (now West Corner), and Beechwood—each having stores, dwellings, schools, a post office, a fire station, and burying grounds. The center village began in 1704, when Thomas James built his farmhouse near a small stream on the road from Hingham to Scituate. By the 1850s, it was the largest of the villages, a combined residential and commercial center with small shops on ground floors and residences above. Here, the center village is the setting of an early post–World War I parade of military units. (Courtesy Helen and William Luscombe.)

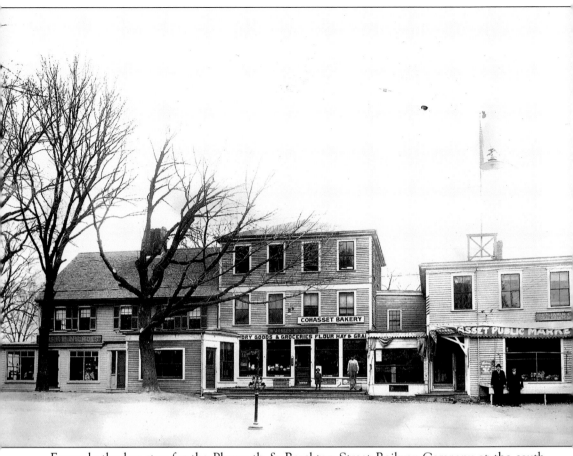

Formerly the bus stop for the Plymouth & Brockton Street Railway Company at the south end of Cohasset Common, Joseph St. John's property, in this 1917 photograph, included his general store, the Cohasset Public Market, Benjamin Tower's real estate and insurance office, and Miss Frances H. Nichols's dry goods store. The telephone exchange and post office, where St. John served as postmaster, were here until 1911, when both were moved across the street to the Tilden Block. In 1918, the Cohasset Improvement Association razed the buildings "for the purpose of preserving and improving the natural beauty and sightliness of the Town of Cohasset and of promoting the health, happiness, and welfare of its inhabitants."

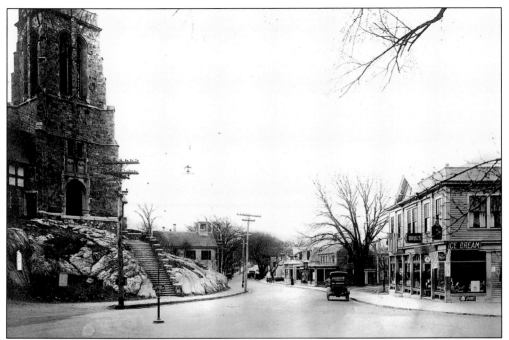

Here we look south from the junction of North Main Street and Depot Court on May 1, 1917. The 1910 Tilden Block was the first in town to be constructed for business purposes. The telephone office remained there until 1958, when rotary phones became available, and the post office, until the 1960s. Three of the old houses already have stores or businesses in their first story. St. John's large tree, where the Tilden Victorian mansion once stood, marks the site of today's Stagecoach Way.

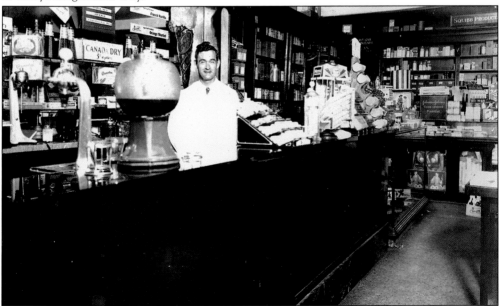

Frank Browne's drugstore was relocated to the Tilden Block from South Main Street in 1913. Here, Minot Browne stands behind the counter of his father's pharmacy, where the town's first soda fountain was found.

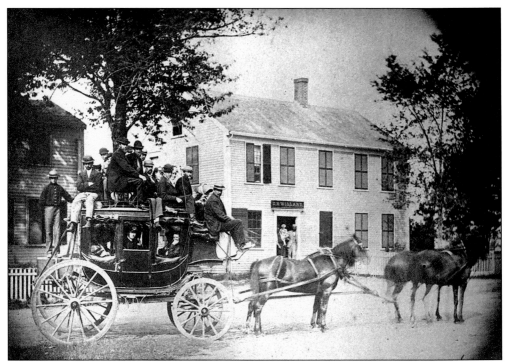

Before the railroad arrived in 1849, a stagecoach running between Greenbush, Scituate, and the Hingham steamboat line passed through the center village at the intersection of Elm and South Main Streets.

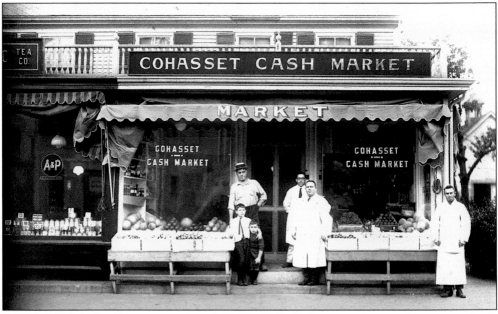

James and Nicholas Simeone purchased C. H. Willard's house and general store on South Main Street in 1910, added a storefront, and opened the Cohasset Cash Market. James stands at center front, with meat cutters Frank Rego behind him and Eugene McSweeney to his right. Next door is the Great Atlantic & Pacific Tea Company.

24

The Guild Band marches down South Main Street in 1892, in front of the only extant Second Empire building in the center village. By 1876, Charles Gross had a grocery store here; by 1912, it was Dr. Evan Wentworth's dentist office. Today it is Village Wine & Spirits.

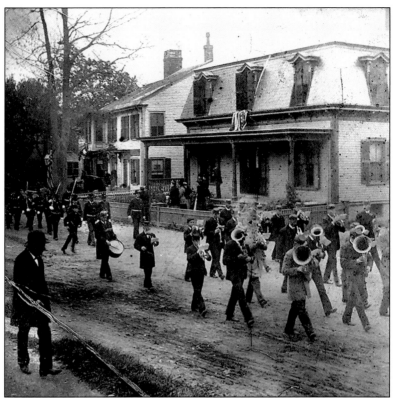

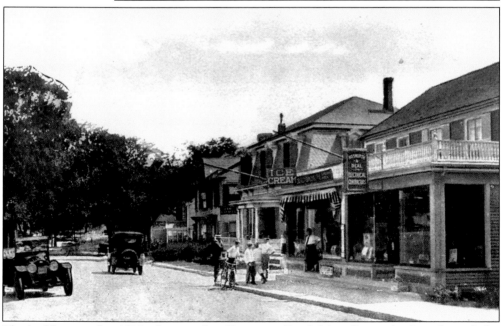

The buildings in this 1920s photograph still exist on South Main Street. At the right with the sign of Bosworth & Beal, electrical contractors, is the former Cohasset Cash Market. To the left is an ice cream store, the mansard-roofed home, the Samuel Bates house (then owned by Edward Ellms), and the 1802 Colonel Newcomb Bates house.

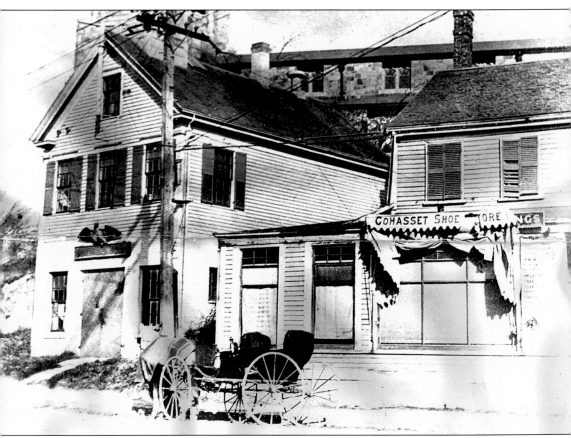

The ship *Serampore*'s carved eagle hangs over the front entrance of Cohasset's first fire station, built in 1848 for the Independence Fire Company No. 1. The building housed the town's first police station and jail from 1913 to 1960, until the new facility was built at 62 Elm Street, and then served as the historical society's gown museum from 1963 to 1983. The photograph dates from *c.* 1910.

At the junction of Elm and South Main Streets, where Cohasset Hardware operates today, Samuel Bates established a tin shop in 1849. His son Allen Collier Bates expanded the business to a full hardware store specializing in stoves in 1857; perhaps Allen is standing outside in this photograph. William McGaw, a local carpenter who donated the Captain John Wilson House to the historical society and built the roller coaster at Nantasket, bought the business in 1912.

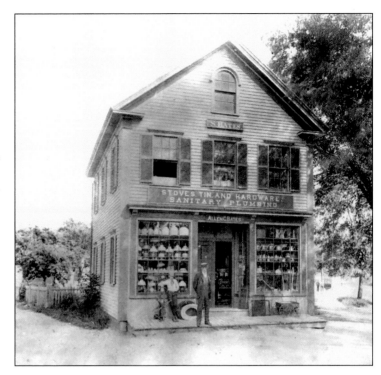

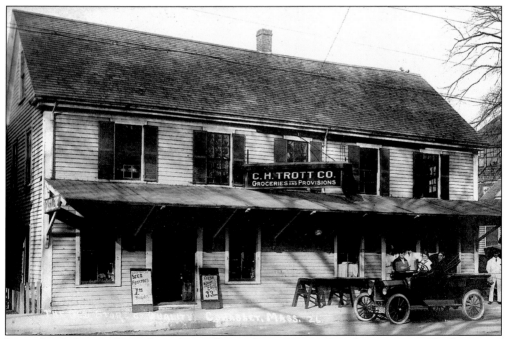

Later the Cohasset Central Market and now the patisserie French Memories, Charles Trott's groceries and provisions store had been owned by grocers Charles Gross and James Nichols from 1890 to 1900.

The Cohasset Inn began as Thomas James's farmhouse in 1704. Enlarged by his grandson Christopher in the mid-1700s, it became an inn on the stagecoach route connecting coastal towns. Over the years, the inn carried several different names—Hillside Inn, Norfolk House, Cohasset Inn, and the Red Lion Inn. This picture dates from the 1940s.

Red Lion Inn

Special Dinners

Served from 6-10 Weekdays — Sat. & Sun. from 12-11

Choice of

MURRAY'S FAMOUS CLAM CHOWDER OR ONION SOUP
FISH CHOWDER
FRESH FRUIT CUP — CHILLED TOMATO JUICE
Fresh SEA FOOD COCKTAIL — Fresh CRABMEAT COCKTAIL
MARRINATED HERRING

— ❷ —

TENDERLOIN TIPS EN BROCHETTE, ONION RINGS	$ 2.25
LARGE BROILED T-BONE SIRLOIN STEAK	3.75
GRILLED CLUB SIRLOIN STEAK	2.75
ROAST PRIME RIBS OF BEEF A JUS	2.75
BROILED FILET MIGNON, MUSHROOM SAUCE	2.75
BROILED MILK-FED CHICKEN	2.50
BROILED SPRING LAMB CHOPS	2.50
BROILED SUGAR CURED HAM, GLAZED PINEAPPLE	2.25
CHICKEN A LA KING, EN CASSEROLE	2.50
FRIED FRESH CLAMS, TARTAR SAUCE	1.50
FRIED SCALLOPS, TARTAR SAUCE	1.50
BROILED NATIVE MACKEREL, LEMON SAUCE	1.50
BROILED NATIVE HALIBUT, LEMON SAUCE	1.50
BROILED NATIVE SCROD, LEMON SAUCE	1.50
BROILED NATIVE 1 LB. LOBSTER, DRAWN BUTTER	2.75
FRIED LOBSTER	2.75
BOILED Hot or Cold FRESH LOBSTER, Drawn Butter	2.75
BAKED SEA CLAMS ON THE HALF SHELL, BACON	2.25

The most expensive item on the Red Lion Inn menu from the 1950s was the T-Bone steak for $3.75.

Joseph Figueiredo offered a full line of the latest designs for menswear at his village tailor shop.

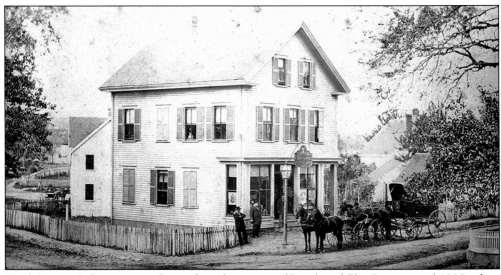

Frank Browne's drugstore was located on the corner of Brook and Elm Streets until 1898, when his building was moved to 55 South Main Street and replaced by the Cohasset Savings Bank.

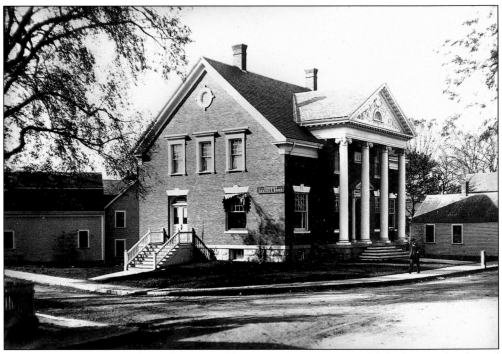

The Cohasset Savings Bank was the town's first financial institution, established in 1845 with Paul Pratt as its first president. For 37 years, the bank was located in an upper room of treasurer Levi Bates's home above his apothecary store on South Main Street. In 1898, the bank built this brick Colonial Revival, and the Odd Fellows Lodge met on the second floor until the mid-1950s.

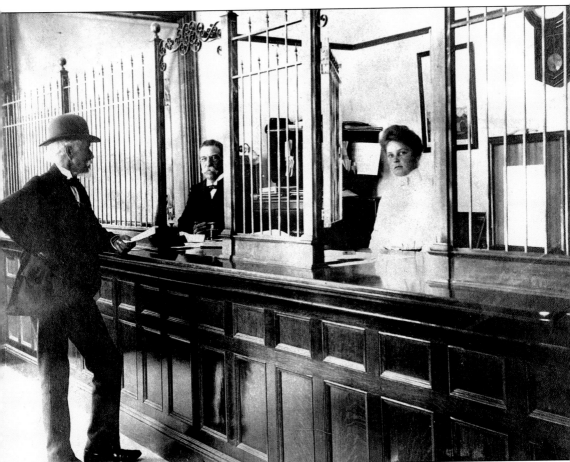

The officers of the Cohasset Savings Bank, c. 1910, pose from left to right: Caleb Francis Nichols, president; Caleb Lothrop, treasurer; and Henrietta Bates, secretary. The decorative metalwork separated customers from the immediate site of their money and helped to keep the bank secure.

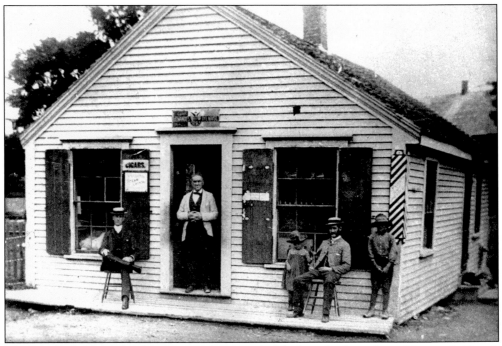

This small shop at 11 Elm Street was an early blacksmith shop, later Newcomb Bates's periodicals store, and then Carlos Tanger's barbershop for over 50 years. Tanger (standing in the doorway) came from the Azores as a sailor. Today the building is Donna Green's artist's studio.

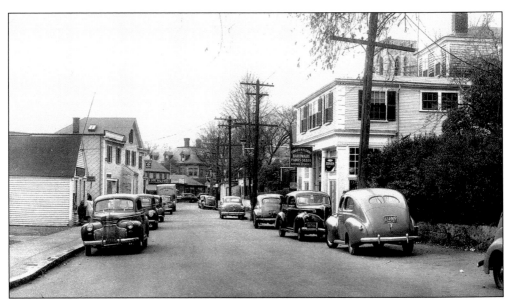

In the 1940s, the Flemings' marine hardware and gift shop at 24 Elm Street operated in a c. 1762 home built by James and Benjamin Stutson. The Fords, Chevrolets, and Mary Fleming's Plymouth help to date this photograph. Fleming's, today, specializes in lamps and gifts.

To the left of Fleming's and today's Dean & Hamilton Realtors is the historical society's maritime museum, or Bates Ship Chandlery. Built on Border Street in the mid-1750s by Samuel Bates, this is the oldest extant 18th-century structure expressly built and used as a chandlery in Massachusetts. It served as company store and counting house for the family fishing business until John Bates died in 1882. Financier Clarence W. Barron acquired the old chandlery in 1912. Jessie and William Cox donated the building to the historical society in 1954; it was moved two years later to its present location.

In 1936, William McGaw gave the Captain John Wilson House to the historical society for its first museum and headquarters. Works of art and 18th- and 19th-century furnishings are featured. Built by shipwright David Nichols, the house was sold to Captain Wilson in 1810 for $475; his descendants sold it to McGaw in 1912, and the house became in turn a teahouse, photographer's studio, and tailor shop. The Wilson House and maritime museum were listed in the National Register of Historic Places in 2002.

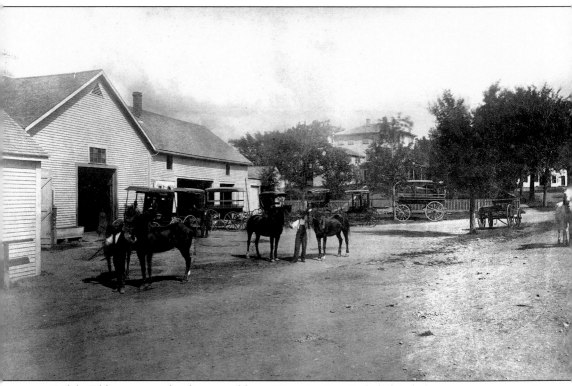

Caleb Tilden operated a livery stable at Constitution Park behind the present community center and a branch near Black Rock House on Jerusalem Road. His brother Amos had a stable halfway between the center village and the harbor at 57 Elm Street. The Tilden horse-drawn barges met the Old Colony trains and the boats at Nantasket; they also transported children to school.

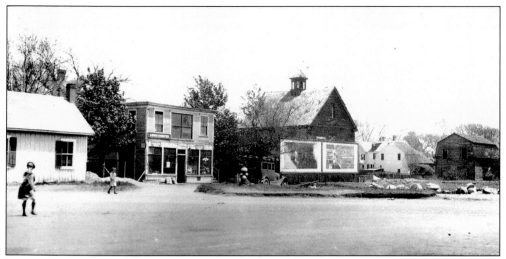

An unfamiliar sight now, these billboards stood at the north side of today's Parkingway, advertising pipe and tobacco and other unidentifiable goods.

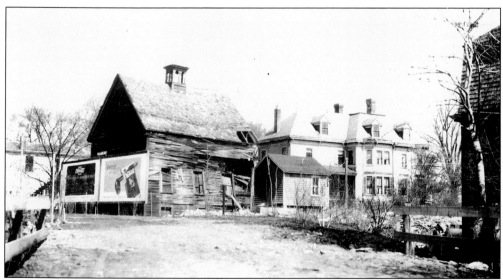

Caleb Tilden's large Victorian house at the right faced South Main Street and stood adjacent to the Tilden Block at the corner of Depot Court and South Main Street. The yard behind the mansion, with the ravaged barn, is now the town parking lot, or Parkingway. The house was taken down in 1953 to make way for stores and Stagecoach Way.

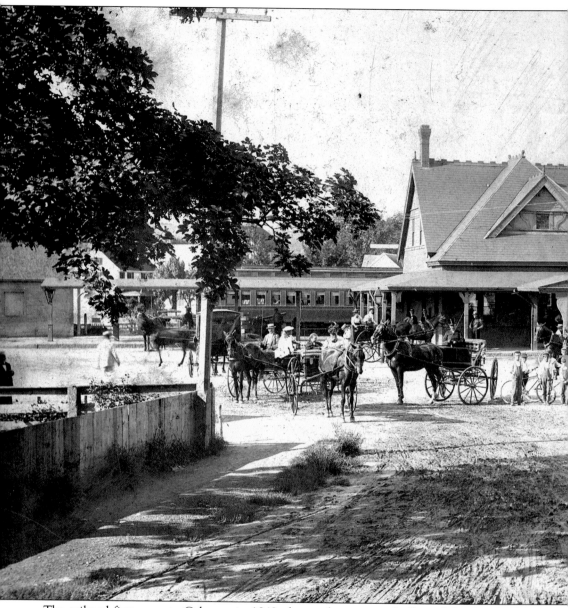

The railroad first came to Cohasset in 1849, due to the concerted effort of the South Shore Railroad Company (a group of local investors) and the Old Colony Railroad Company. Travel to Boston became easier and more comfortable than it had been by small packet boat or stagecoach. In 1893, Old Colony merged with the New York, New Haven, & Hartford Railroad

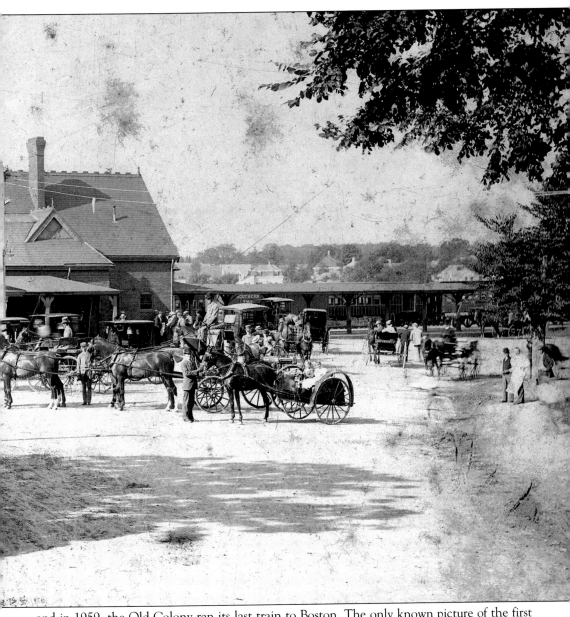

and in 1959, the Old Colony ran its last train to Boston. The only known picture of the first railroad station shows an elaborate structure, which burned to the ground Thanksgiving night 1857. The third station, shown in this 1890s photograph, still survives and was converted to a restaurant, now Bernard's.

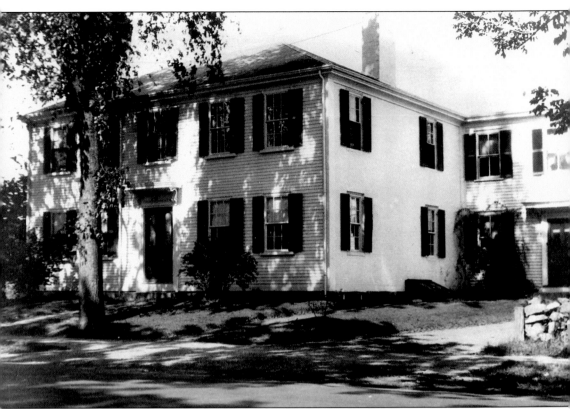

Purchased in 1975 from the Roman Catholic Archbishop of Boston, the 1821 brick-end Federal-style Caleb Lothrop House was the headquarters of the historical society for 28 years. In 1976, the house was listed in the National Register of Historic Places. Caleb Lothrop (1799–1862), a ship owner and ship chandler, with a wharf at the inner end of the harbor, was also a selectman and treasurer. In 2003, the society sold the house and moved to new quarters in the former public library at 106 South Main Street.

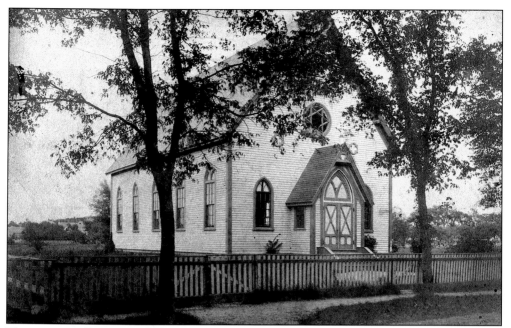

There was no Roman Catholic Parish in Cohasset until after the memorial service held for the victims of the wreck of the Irish brig *St. John* in 1849. Soon religious services were held in private homes, and in 1875, a Gothic-style chapel was built on South Main Street and named for St. Anthony of Padua.

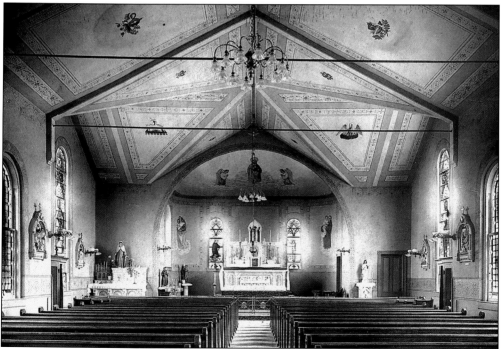

This interior view of the original St. Anthony of Padua Roman Catholic Church was taken in 1912. After the construction of the present brick church in 1964, the wooden building was used for occasional meetings until it was demolished in August 1979.

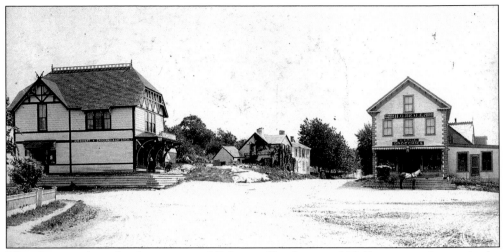

West Corner, where the three towns of Cohasset, Hingham, and Hull meet, was known in the 19th century as "Jerusalem Village." Native Americans had called the area *Tugnamug;* today it is called West Corner, named for Charles West, who operated the store on the right with H. O. Beal. On the left is H. H. Covert's grocery and dry goods store, later the Nantasket Branch Library. The building in the center is now Di Nero's restaurant.

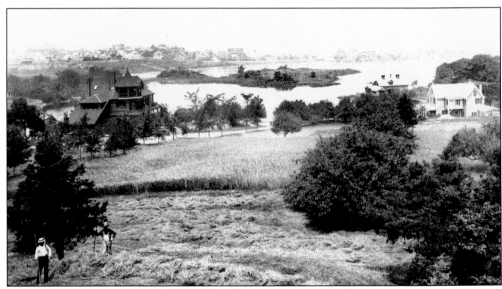

To the southeast of West Corner, Jerusalem Road runs by Straits Pond, dividing Cohasset from the town of Hull. This *c.* 1890s photograph was taken from the porch of Henry Hyde's summer cottage, Cedar Ridge, at 720 Jerusalem Road. Four modern ranch-style houses now occupy the land at the foot of the hill.

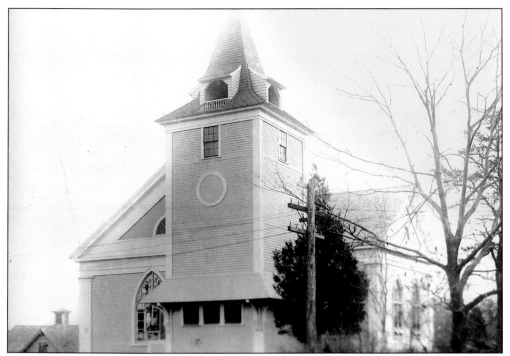

Built in 1845, the Methodist Episcopal Church on the Cohasset side of Hull Street was affiliated with the Southern New England Methodist Circuit. The parish was founded in 1817 and lasted until the early 1900s, when the newer Pope Memorial Church absorbed its membership. The Hull Street church was known locally as the "Huckleberry Church" because fund-raising efforts for its construction included picking and selling huckleberries.

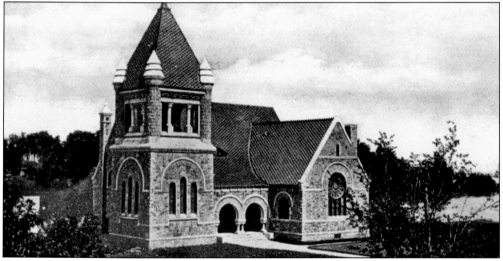

Near the western end of Jerusalem Road and his 66-acre estate, Col. Alfred Pope, whose company made Pope automobiles and Columbia bicycles, built a Romanesque-style church in 1900 in memory of his son Charles, who drowned at age 18. In 1923, the nondenominational Pope Memorial Church became a Methodist church. Later, in 1980, the trustees sold the property to the South Shore Hellenic Church, and it became the Nativity-Assumption of the Virgin Mary Greek Orthodox Church.

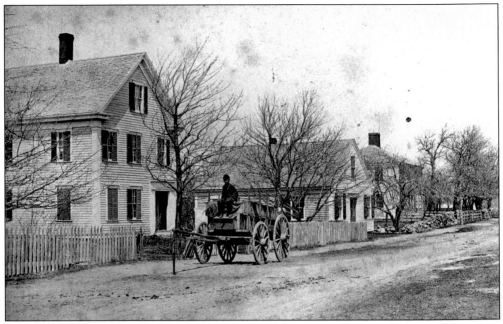

Beechwood, with its farms and small country stores, library, church, post office, and fire station, was well established by the early 1900s. This building still exists but now stands on the opposite side of the road at 432 Beechwood Street. Howard Pratt built and operated it as a general store until his death in 1879. In this photograph, the wagon driver seems to be awaiting the arrival of a team of horses nowhere to be seen.

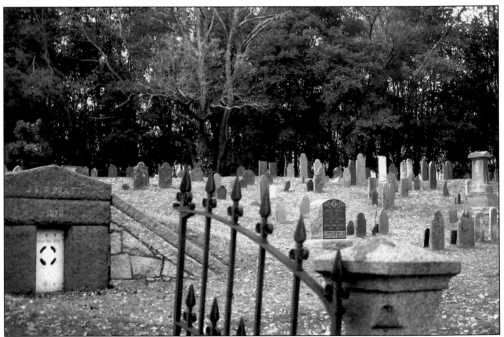

The Beechwood Cemetery, on land originally owned by early settlers Aaron Pratt and Isaac Bates, dates back to 1737, when it was divided into six lots. The handsome wrought- and cast-iron gates date from the cemetery's expansion in 1874.

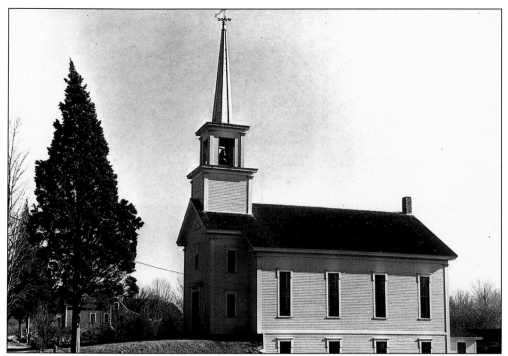

After years of walking six miles back and forth to church in the center village, residents of Beechwood raised funds to build the Beechwood Congregational Church on land contributed by John and Aaron Pratt. The church was completed in 1866 at a cost of just over $5,000. (Courtesy Rebecca Bates-McArthur.)

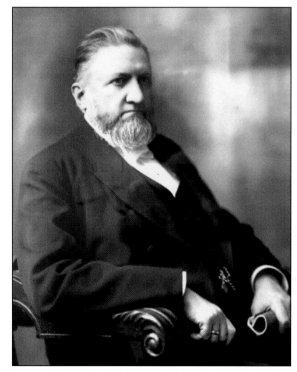

Rev. Daniel W. Waldron of the City Missionary Society preached at the dedication of the church on January 15, 1867, and at the service after the church's renovation on January 17, 1905. (Courtesy the Snowdale family.)

This bucolic country scene (now Riverview Drive) shows Elmer Bates's farm c. 1898. Bates sold dairy products to resort hotels in Nantasket. By this time, most of the remaining large-scale farms were located in Beechwood, which had always been the center of agriculture in town. (Courtesy Rebecca Bates-McArthur.)

Three

CIVIC LIFE AND SCHOOL BEGINNINGS

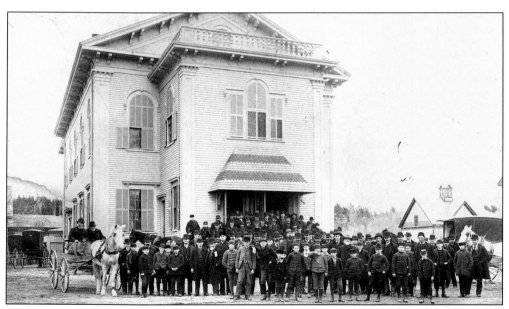

In the years 1860 to 1960, during a time of great change, Cohasset residents were fortunate to have civic-minded citizens who gave endless amounts of time, energy, and creativity to furthering the best interests of the community. At town meetings, voters supported plans to centralize the public school system from eight small school districts, modernize the fire and police departments from volunteer and part-time officers, and to meet the expanding role of local government, build the present-day town hall. In this March 4, 1889, photograph, Cohasset voters (in those days, all male) and children (all boys) pose in front of town hall, built in 1857. Prior to that, town meetings were held at the Cohasset Academy on Highland Avenue, and before that, at the meetinghouse on Cohasset Common.

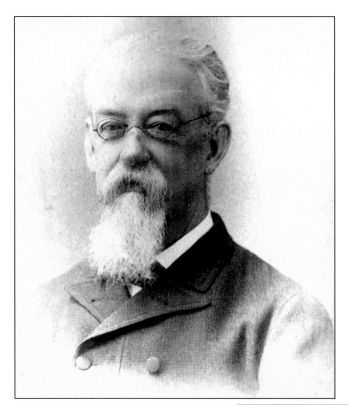

John Quincy Adams Lothrop (1824–1894) served the town as selectman and town moderator from 1865 until his death. Not one to be found relaxing, he was also Norfolk County commissioner, deputy collector of customs for the Port of Cohasset, a ship chandler, and an insurance agent, as well as representative to the General Court in 1865–1866 and 1887.

Well-known around town and town hall, sisters Eleanor and Frances Downs, who lived on James Lane, were amateur gardeners and the proud owners of the first Ford in Cohasset, a worthy successor to their horse carriage, lined with purple cloth. Eleanor was tax collector for 17 years, elected during the Depression when President Roosevelt closed the banks. As part of her duties, she collected the poll tax, which levied $1.00 on the head of each family and $10.00 on each household in town. (Courtesy John Connell.)

Outspoken, energetic, and resourceful, William Otis Souther Jr. (1879–1930) was elected selectman at age 31, the first local politician to expend considerable funds in a campaign, thus ensuring his victory over Joseph Bigelow by a narrow six-vote margin. A prolific writer, Souther produced annual broadsides such as this one from 1929.

THE ELECTION OF
SOUTHER
will result in

ELIMINATING POLITICAL MACHINES AND STOP THE SQUANDERING OF TAXPAYERS' MONEY

LOW BUT EQUITABLE REAL ESTATE VALUATIONS

TOWN AFFAIRS CONDUCTED ON A STRICTLY BUSINESS BASIS

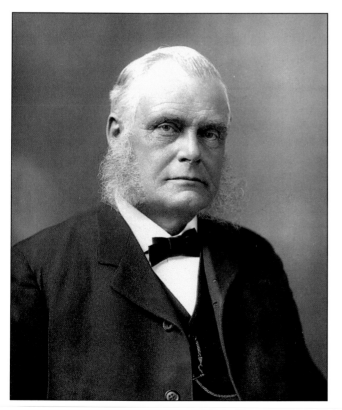

Philander Bates (1836–1918), considered the most prominent man in Cohasset at the turn of the 20th century, was selectman and assessor for over 40 years, overseer of the poor for 37 years, superintendent of the streets for 20 years, moderator of town meeting for 11 years, trustee of Cohasset Savings Bank for 42 years, and deacon of the Second Congregational Church for 43 years.

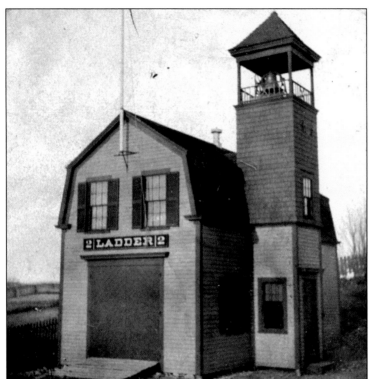

The 1895 Beechwood Fire Station was one of three firehouses of similar age in town. By 1980, the station was no longer large enough to hold the newly acquired pumper. Despite efforts to preserve the historic structure for use in town, the building was sold in 1983 and moved to Scituate to begin a new life as a barn. The site is now a basketball court.

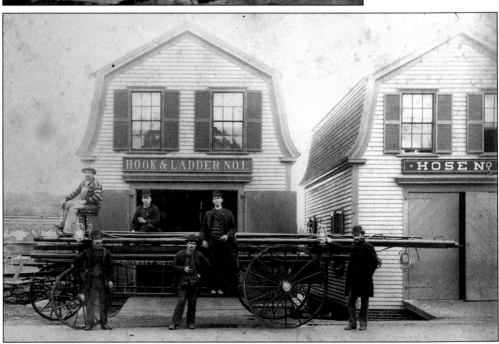

The "Ugly Twins" stood side by side at the harbor where Veterans Memorial Park is located today. Cleverly nicknamed, these buildings were combined in 1913 by architect George Newton to form the first Central Fire Station, which lasted until 1960, when a modern facility was built on Elm Street.

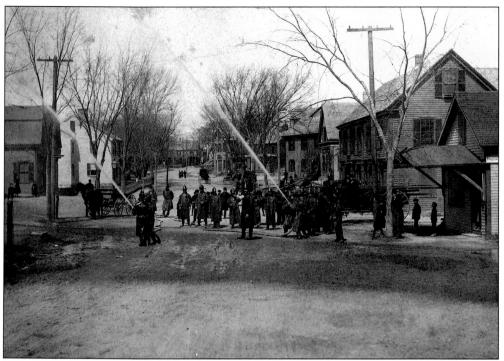

Since 1849, New England firemen have been competing in musters, testing their skills and providing entertainment for their communities to enjoy. The object of the muster is to see which company can shoot a stream of water the farthest. Prizes are also given for the engine in the best condition, the company coming from the longest distance, and the company making the best appearance. This photograph from the 1880s shows a muster at the corner of Brook and South Main Streets.

The Cohasset Volunteer Veteran Firemen's Association won the muster on July 4, 1914.

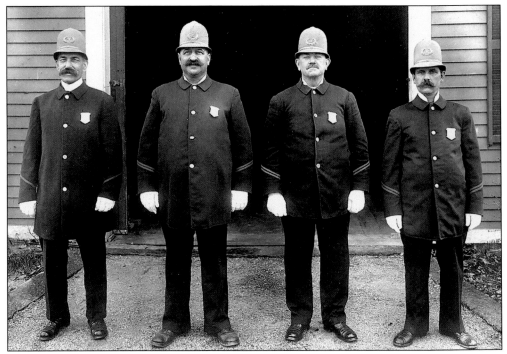

From 1901 to 1916, the town employed night police who shared law enforcement duties with the town's police officers by taking responsibility for the security of the town at night. Shown *c.* 1914, standing from left to right, are Joseph Antoine, Frank Jason, Sidney Beal, and John Grassie.

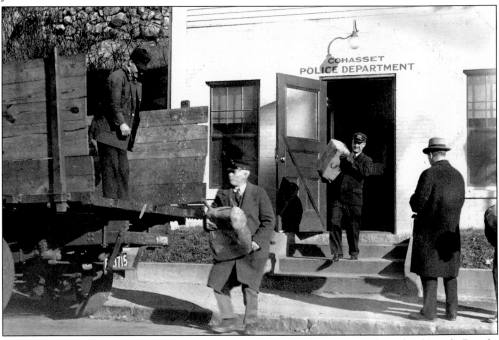

During Prohibition, on one night alone, 375 cases of whiskey were seized south of Sandy Beach. Shown here are members of the police force loading cases of liquor for disposal in Boston.

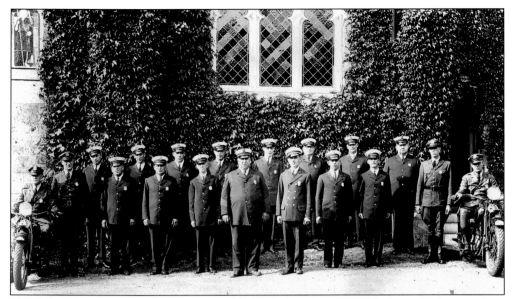

The police department in the 1930s stand behind the station near the stained-glass windows of St. Stephen's. Patrolmen Benjamin Curley and John Rooney are seated on the town's two state-of-the-art siren-equipped motorcycles. At the center front are veteran officer Frank Jason and Chief of Police Hector J. Pelletier. Appointed in 1927 at the age of 24, Pelletier (1903–1976) was the youngest in Massachusetts to hold that position. Held in high esteem during his 40-year career, he served as secretary-treasurer of the Massachusetts Chiefs of Police Association for 21 years and was a major fund-raiser for the Jimmy Fund, aiding research and treatment for children with cancer.

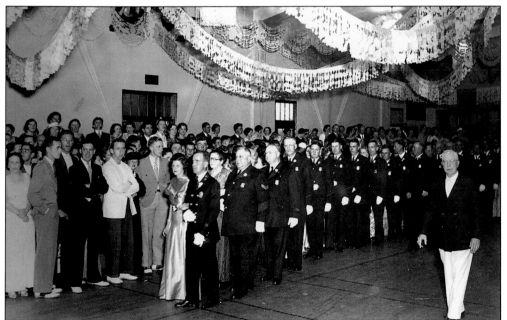

Chief Pelletier and his wife, Helen, lead the grand march in the 1930s at the annual policeman's ball in the decorated auditorium of the Ripley Road School (now the town's library). Nationally known orchestras and entertainment made this ball a festive affair.

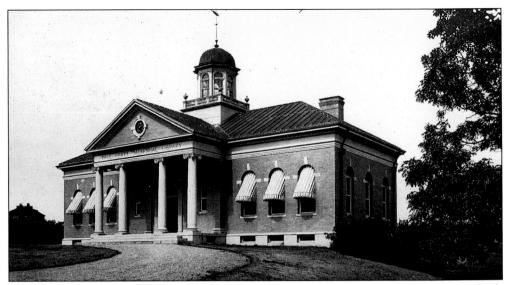

The first centralized public library, designed by Cohasset architect Edward Nichols, was built with money from the estate of Paul Pratt and land donated by Samuel Snow. Originally, this handsome structure held two libraries, the privately funded Paul Pratt Memorial and the town-funded Cohasset Free Public Library. At the 1903 dedication, Rev. Charles Merriam, a director, looked forward to "a place where all, especially the young, can . . . find both recreation and profit amid wholesome surroundings." In 2003, the library moved to the former Osgood School, and the historical society purchased the building for its headquarters.

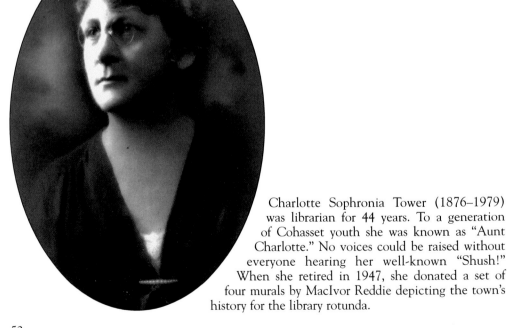

Charlotte Sophronia Tower (1876–1979) was librarian for 44 years. To a generation of Cohasset youth she was known as "Aunt Charlotte." No voices could be raised without everyone hearing her well-known "Shush!" When she retired in 1947, she donated a set of four murals by MacIvor Reddie depicting the town's history for the library rotunda.

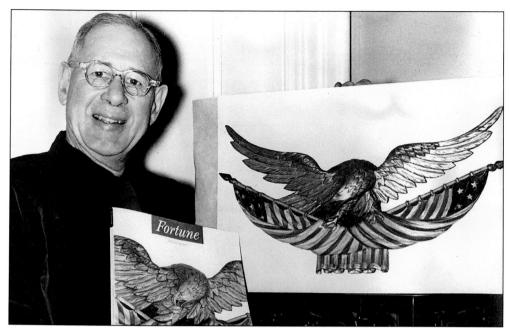

Gilbert S. Tower (1885–1984), a leading town historian for many years, was appointed honorary town engineer by the selectmen, undoubtedly for his work on the Panama Canal construction and as a marine architect at the Fore River Shipyard in Quincy. His series of large historical maps of Cohasset are still widely used today. Here, Tower holds a watercolor of an eagle, carved by William Beal of Cohasset, which was used as the February 1962 cover illustration of *Fortune* magazine.

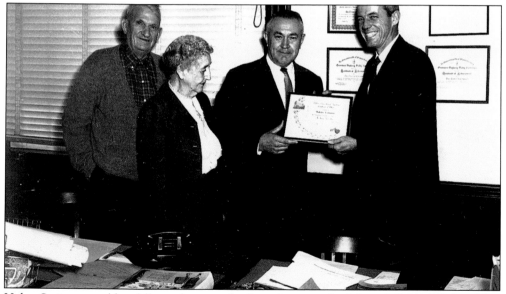

Helen Scripture and her fellow selectmen, Ira Stoughton, on the left, and George McLaughlin, on the right, present town accountant Malcolm Stevens a certificate of merit in 1961. Together with Norman Card, Scripture and Stoughton virtually ran the town in the 1950s. Scripture was the first woman elected to serve on a board of selectmen in Massachusetts, holding office from 1952 to 1970; at age 84, she was defeated by Mary Jeanette Murray.

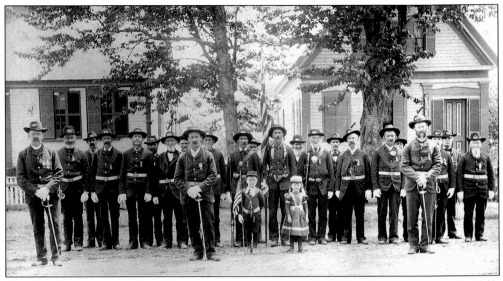

The Grand Army of the Republic was an organization for Civil War Union veterans. In 1868, the commander in chief of the G.A.R. issued an order that all posts set aside May 30 as a day for remembering those who sacrificed their lives in the Civil War, beginning what we now know as Memorial Day. Here in the 1890s, members of Cohasset's Henry Bryant Post No. 98, named for a summer resident and prominent Boston physician, stand at attention on Summer Street with young mascots in the foreground. Last on the right is William Thayer, Cohasset's first volunteer.

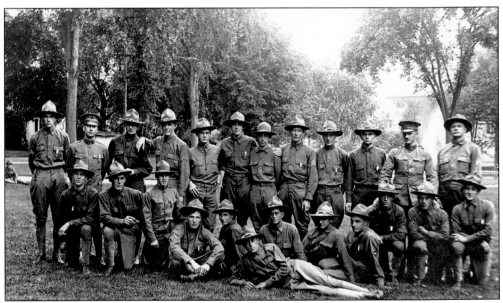

Soldiers gather on Cohasset Common in the summer of 1917. Several wear the Cohasset medal, given to men in uniform that year. In the back row, second from the right, is George H. Mealy, who was killed in action in France in 1918 and for whom the Cohasset American Legion Post is named.

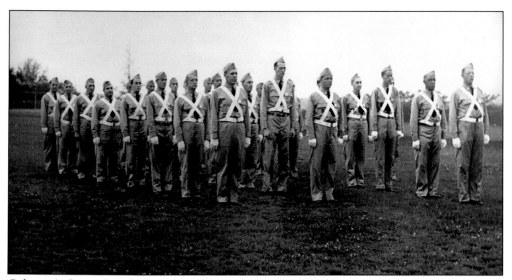

Cohasset's State Guard unit, the 17th Company, 28th Infantry Division, trained at Camp Perry, Cohasset. Their primary goal was to prevent saboteurs from landing on our shores during World War II.

For Representative
Third Plymouth Representative
District
Vote for

"Serg't" WILLIAM H. MORRIS
OF COHASSET

William Morris ran unsuccessfully for state representative. The second commander of the George H. Mealy Legion Post, he was town clerk for 26 years and, before that, town moderator for 11 years.

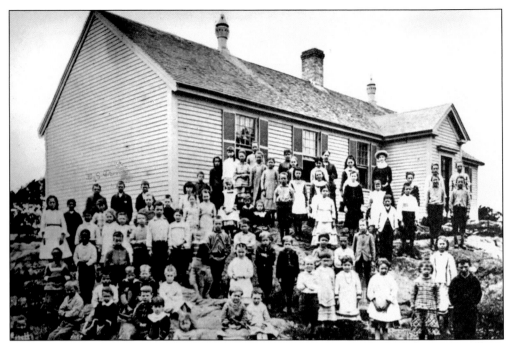

The Centre District Schoolhouse, built *c.* 1824, stood on a ledge overlooking the center village. One-third of the children from each of the North and South Districts were now educated here. The school operated until 1891, when it was closed along with those located on Jerusalem Road and in the South District, after the Osgood School, the town's first central school, opened on Elm Street.

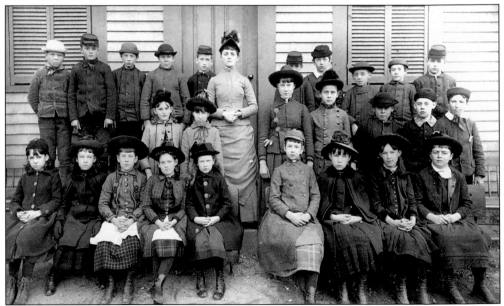

Children and their teacher pose for a class picture in 1888 in front of the North District Grammar School, at the junction of North Main Street and Jerusalem Road. One cannot help but wonder if this was normal school attire or whether mothers insisted on dress-up for the annual school picture.

56

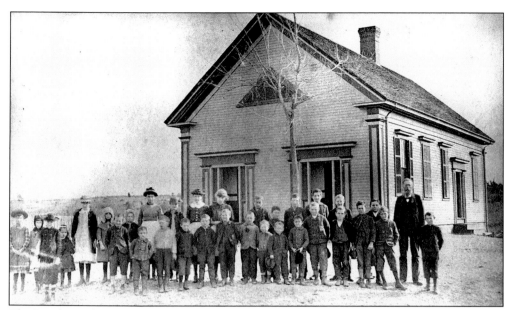

The Beechwood Elementary School outlived the other eight district schoolhouses until it, too, closed its doors in 1933, over the strong objections of Beechwood parents. Some protested by keeping their children at home rather than sending them to the central school by bus, claiming that they did not want their children to be away from home all day. Built in 1861, the "little white schoolhouse" educated three generations of children.

Daniel Tower and his son Gilbert stand in front of their 29 Beach Street home, the former Cohasset Academy, which moved from its location on Highland Avenue in 1857, when the town hall was built. The academy, similar to Derby Academy in Hingham, was started in 1776 by a group of concerned citizens upset that the town was spending only 50¢ per pupil per year. Tuition was set at 44¢ a week plus firewood. The academy never succeeded, however, and by 1812, with war ongoing, it had all but shut down.

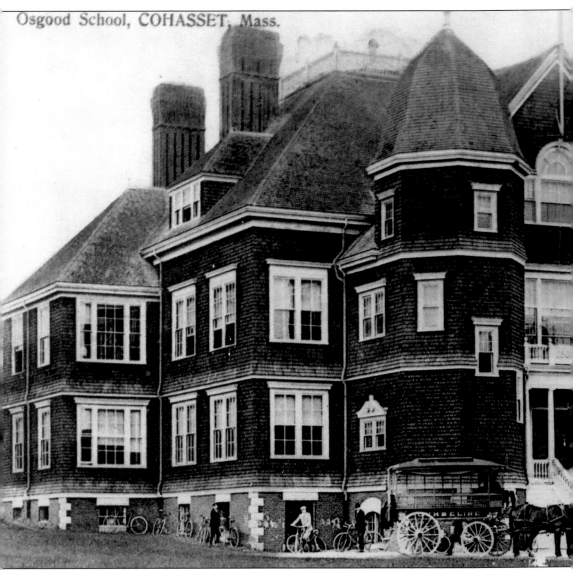

Cohasset's first central school was named for Rev. Joseph Osgood, who pioneered the effort to replace the district schools with a centralized one, allowing for uniform improvements in grading, curriculum, and teaching methods. The three-story building had a gym on the third floor and classrooms on the first and second floors. The Osgood School first held all grades, and later 7th through 12th, closing in 1951, when the new high school on Pond Street opened. Today, the town's fire and police stations occupy this site.

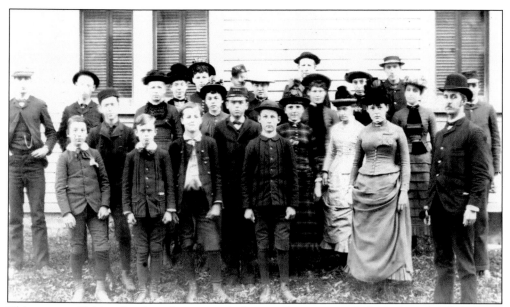

This group of high school students, or scholars, as they were called, poses with Edith Gross Parker, a teacher, and Arthur Stanley, headmaster, c. 1890.

E. Pomeroy Collier, the son of Capt. James Collier, was an assistant teacher at the high school and a member of the first Committee on Town History. Collier wrote the chapter in *Geneologies of the Families of Cohasset Massachusetts* called "Cohasset's Deep Sea Captains," giving details of about 50 world-traveling merchant captains, including his father.

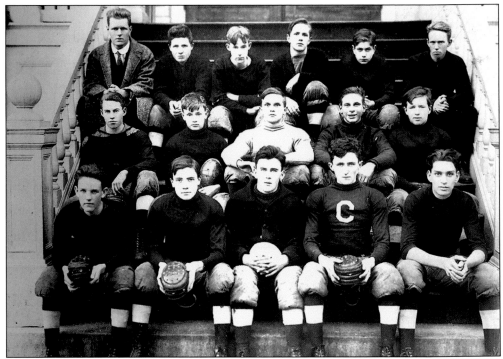

The high school football team of 1915 sits for its picture on the front steps of the Osgood School. Among the many changes that have occurred in the game is the substitution of the modern plastic helmet for the leather ones shown here.

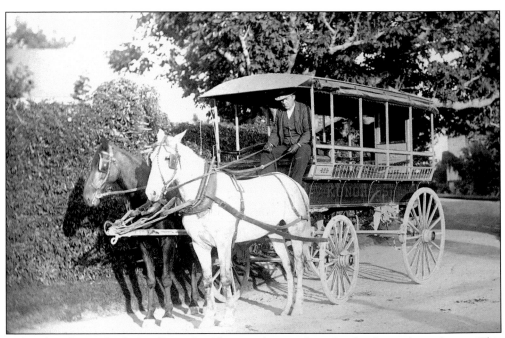

Before the advent of today's yellow school bus, pupils arrived at school in horse-drawn barges. This one, driven by Mr. Stoddard, is named Konohasset, a variant in spelling of the town's name.

Four

WORKING HARBOR

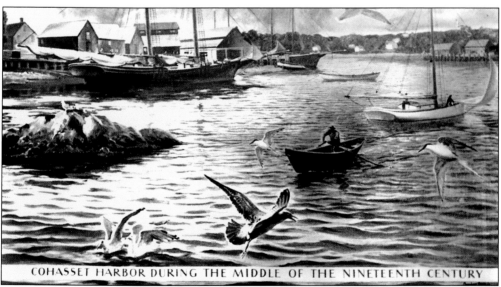

COHASSET HARBOR DURING THE MIDDLE OF THE NINETEENTH CENTURY

By the early 1700s, shipbuilding had begun at Ship Cove, today's Cohasset Harbor. As the town grew, the harbor became the center of commercial activity. Shipbuilding and mackerel fishing provided occupation for many in Cohasset until improved technology allowed for machine-powered ships, often made of steel. The age of sail was over by 1900, replaced by recreational boating, with large sailing boats at the Cohasset Yacht Club leading the way. This MacIvor Reddie mural depicts the working harbor.

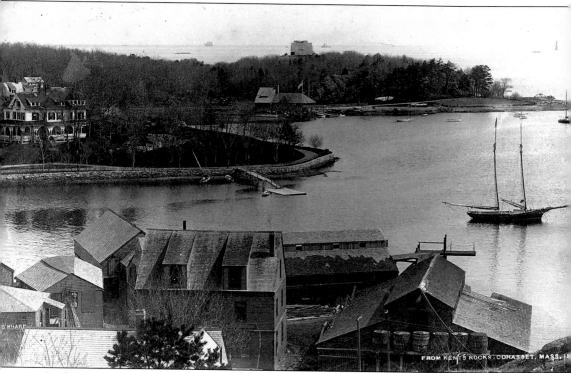

In this 1898 view, we look north from Kent's Rocks, the high ledge at Border Street. The Tower brothers' wharf and buildings are in the foreground, and across the harbor at the left is Clarence Barron's Victorian summer house. Beyond, on the north shore, is the Cohasset Yacht Club, established in 1894. By this time, the fleets of large mackerel fishing schooners were gone, and the only one in view is a small two-masted vessel moored on the right.

Sailboat racing dominated the early years of the yacht club. From the 1920s, the women members proved formidable opponents. To promote women's sailing at the national level, in 1925, Charles Francis Adams, club member and former secretary of the navy, presented a cup in honor of his wife, Frances. The Cohasset crew won the Adams Cup four times, from 1935 to 1938. Pictured here in 1937 are, from left to right, the following: Joan Chapin Waters, Frances McElwain (Wakeman), Frances Williams Perkins, and Katherine Johnson Fisher. Wakeman was nominated for the New England Women's Sports Hall of Fame in 2003.

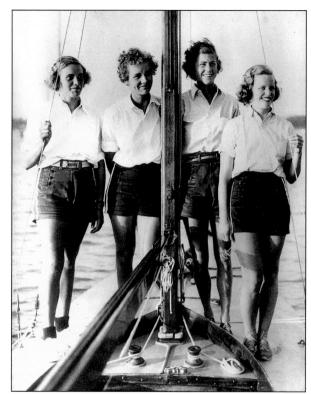

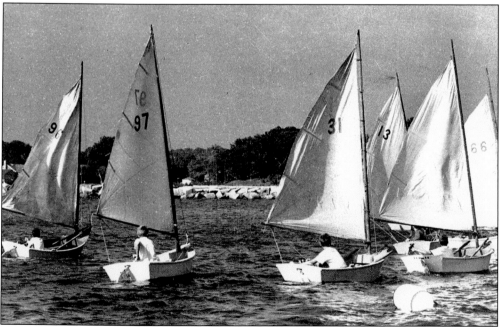

For years the primary training sailboat for youngsters at the yacht club was the omnipresent Rookie Class, eight feet long and useful as a tender as well. Here, part of the Rookie fleet maneuvers for position at the harbor in 1943, a scene repeated many hundreds of times during the Rookie's long career.

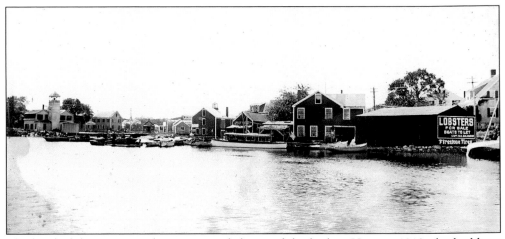

The head of the cove was the most crowded part of the harbor. Here, c. 1912, the buildings include, starting on the left, the Central Fire Station with its bell tower, Guild Hall, Custom House, Sylvester's Fish Market, South Shore Boat Yard, and Salvador's Lobster Shop and Boat Rental, formerly a bowling alley.

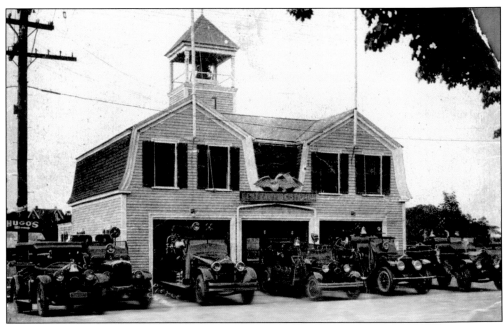

This 1925 photograph shows the Central Fire Station, which was demolished the year after the new station was built on Elm Street in 1962. The open space created at the harbor became Veterans Memorial Park.

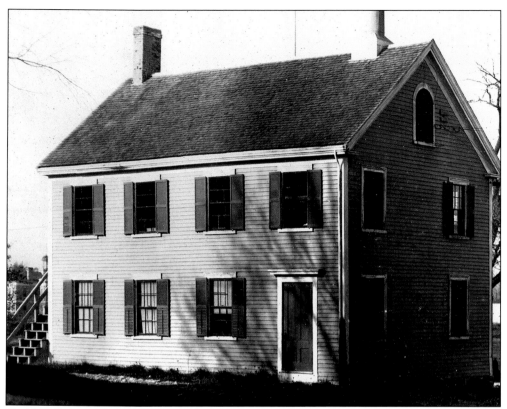

Guild Hall, formerly at the corner of Summer and Border Streets c.1903, was built in the 1850s as the U.S. Custom House and from 1873 housed the Harbor District School. After the central school was established in 1891, the building was leased to the Village Guild Association in 1893 and became known as Guild Hall. In 1916, it was moved across the street to 88 Summer Street and, in 1922, was leased to the new American Legion Post No. 118.

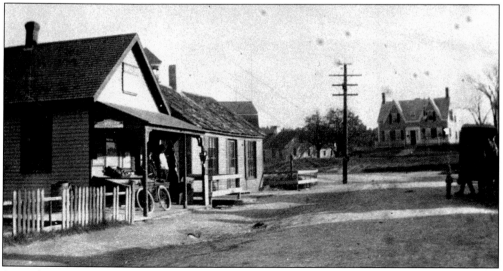

Several stores were located on Cove Bridge over James Brook at the head of the cove. In 1908, they included Sylvester's Fish Market and Caleb Nichols's Cohasset Supply Company.

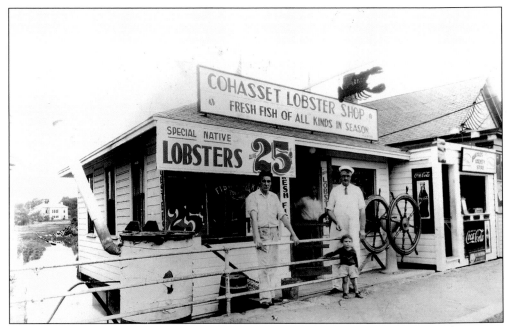

Also located on the bridge were the Pattison family's Cohasset Lobster Shop and Gaetano Bufalo's Variety Shop.

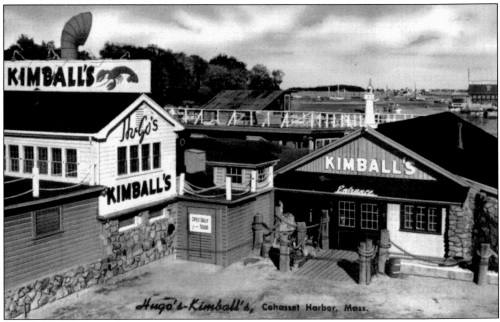

Hugo Ormo, who married Peter Kimball's granddaughter Edith, opened Kimball's Lobster Shop at the head of the cove in 1922, and in 1940, Hugo's Lighthouse on Tower Wharf. Both were sold after his death to John Carzis in 1948. These, along with Hugo's Shack, which Carzis also operated at the cove, attracted tourists from around the nation. Kimball's, which closed in 1968, was destroyed in a spectacular nighttime fire in 1972, as was Hugo's Shack in 1973. Hugo's Lighthouse closed in 1982, after Carzis died; today, it is the Atlantica restaurant. (Courtesy John Connell.)

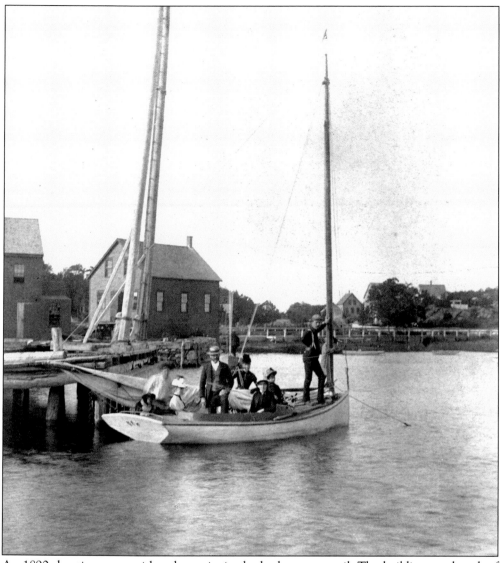

An 1890s boating party with a dog waits in the harbor to set sail. The buildings at the wharf later became part of Kimball's Lobster Shop.

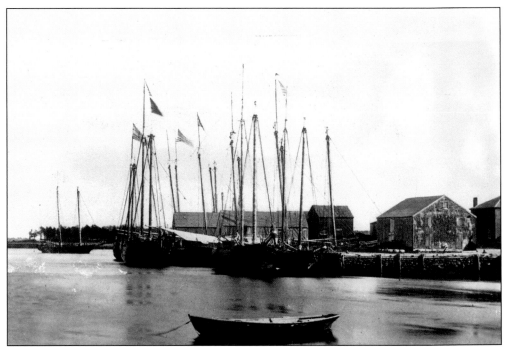

On April 19, 1875, Cohasset's mackerel schooners were tied up at the family-owned Snow, Tower, Bates, and Lawrence Wharves. These fast two-masted schooners fished from spring through fall in the Gulf of St. Lawrence, traveling back to Cohasset to land each catch and making as many fishing voyages as they could before winter weather curtailed their season.

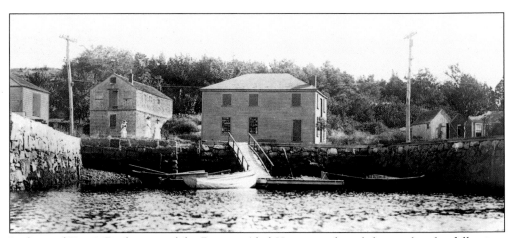

In front of Kent's Rocks, named for Deacon Abel Kent, are, from left to right, the following: Bates Wharf, which dates back to the 1750s; the shop owned by Michael Neptune Brennock, a salvage diver who had been born at sea and worked on the building of the second Minot's Ledge Lighthouse; the Bates Ship Chandlery; and the town landing, Lawrence Wharf, given in 1907 by Susannah Wendell (Lawrence) French.

Jonathan Beals Bates (1795–1879) was the most prolific builder of sailing vessels in the town's long maritime industry. There is evidence that he also built houses when he was not at the shipyard at Margin Street, located on the north side of the harbor.

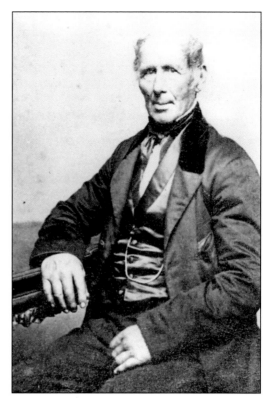

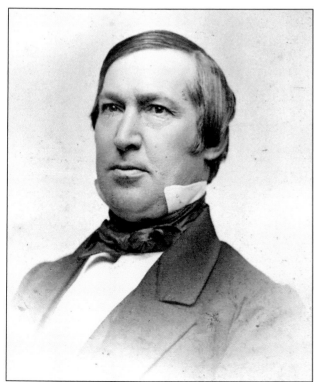

John Bates (d. 1882) was the last of his family to operate the fishing and trading business. In 1848, he added a group of new mackerel schooners to the Bates fleet and maintained five square-riggers in foreign and transatlantic trade. After his death, the Bates Wharf and Chandlery were sold to Clarence Barron.

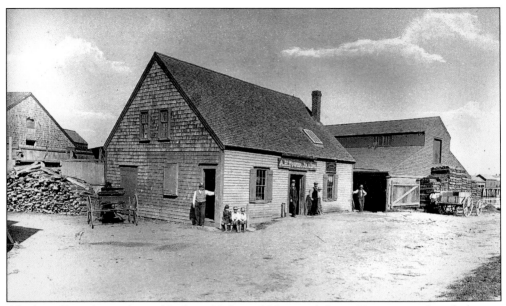

Abraham Tower's grandsons Abraham H. Jr. and Newcomb Bates Tower turned to dealing in coal, lumber, and yacht supplies when the fishing business ceased to be profitable. At their Border Street buildings on Tower Wharf, they sold everything from lumber to molasses, house paint to bamboo fishing poles, and marine fittings to barrels of sugar. In 1933, the buildings were taken down to make way for the Lobster Claw restaurant.

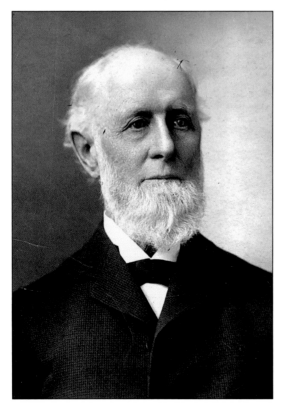

Abraham Hobart Tower Jr. (1829–1904) of North Main Street was a third-generation ship owner and merchant in a family dedicated to making their living from the sea and spending much of their lives working in public service to their community. Tower was treasurer and collector for 40 years.

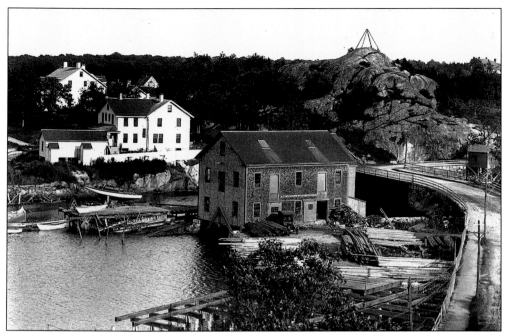

At the entrance to the tidal estuary called "the Gulf," at Border Street, Tower brothers' lumber wharf and boatyard were built on the site of a grist mill that had burned in 1862. Beyond the lumberyard are the two buildings of the U.S. Lighthouse Service at Government Island. The early wooden Mill River Bridge has been replaced by the cast iron Gulf River Bridge.

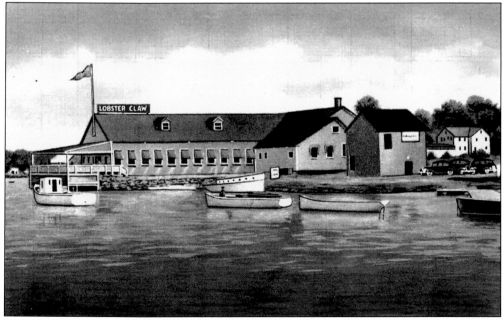

John Macris and John Fitzgerald Jr. opened the Lobster Claw in 1933 on Tower Wharf. The wharf buildings had been razed to allow for construction of this modern restaurant. Never a success, the Lobster Claw closed after a few years, and in 1940, the property was leased to Hugo Ormo, who opened Hugo's Lighthouse.

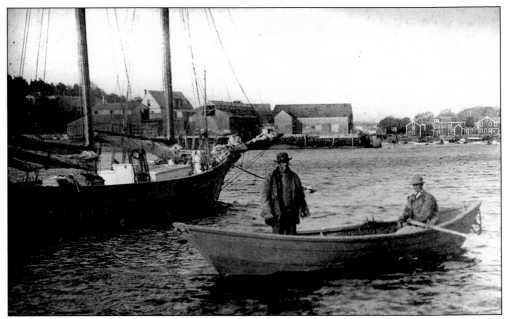

Lobstermen Antoine Figueiredo and Joseph Francis Silvia Jr. pose in a dory next to a medium-sized schooner. The buildings of Tower Wharf are in the background.

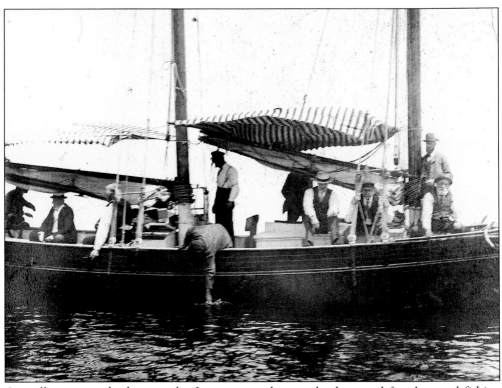

A small two-masted schooner, the *Jason* was used as a pilot boat and for chartered fishing parties. Canopies provided boaters with comfort from the relentless sun.

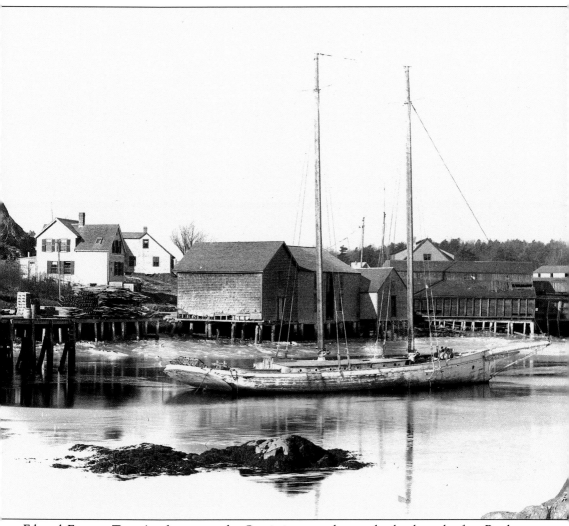

Edward Everett Tower's schooner yacht *Gracie* is moored near the lumber wharf at Border Street. Built in 1875 by Jonathan Beals Bates, she was a familiar sight off Cohasset shores until her end in 1900.

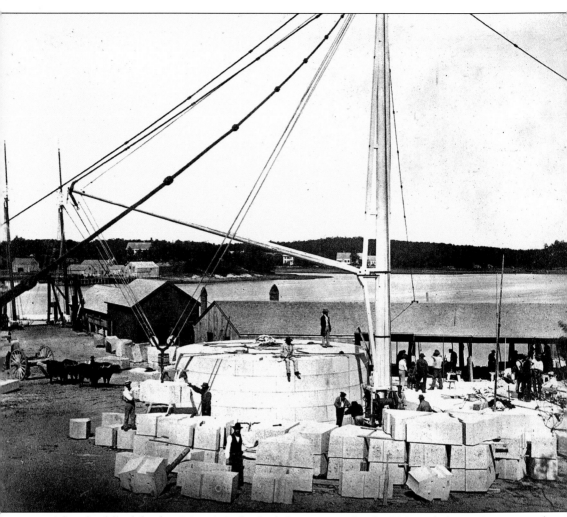

After the fall of the first Minot's Ledge Lighthouse in 1851, the U.S. Lighthouse Service used Gulf Island from 1858 to 1859 as the site for stonecutting more than 1,000 granite blocks from the Quincy quarries for the second lighthouse. An engineer's office, observatory, large storage shed, boathouse, two homes for keepers' families, and buildings for fuel storage and stone cutting, as well as a semaphore beacon, were built during construction. (Courtesy U.S. Coast Guard in the National Archives.)

Minot's Ledge Lighthouse was completed in 1860 at a cost of $300,000. Located two and a half miles from Cohasset Harbor, the lighthouse remained a manned station until 1946. In this *c.* 1907 photograph by Milton Reamy, head keeper at Minot's from 1887 to 1915, one can see on the right of the 114-foot tower, above the doorway, the so-called "Longfellow chair," used by the author when he visited and others who had difficulty climbing the long entrance ladder. Minot's lantern became solar powered in 1983. (Courtesy National Archives.)

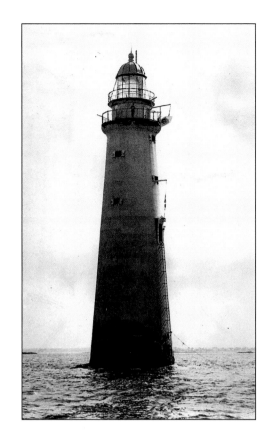

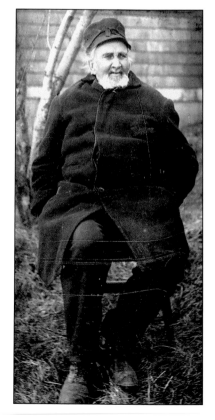

Capt. John Nowell Cook (1809–1896) was a master rigger employed in building Minot's Ledge Lighthouse. He made the model for the derrick used in raising the stones. His small house at 23 Bow Street still remains.

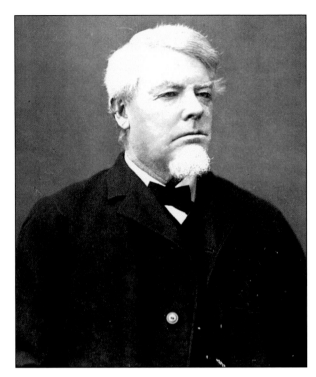

Joshua Wilder Jr., of the Hingham clockmaking family, was the first head keeper of the second Minot's Ledge Lighthouse. He was appointed in September 1860 and left the position in August 1861.

The U.S. Lighthouse Service reservation at Government Island (formerly Gulf Island) was the shore station for Minot's Ledge Lighthouse. The head keeper's house, now gone, is at the left. On the slope of Beacon Rock, at the right, is the former engineer's office, now used as a storage building for the harbor master.

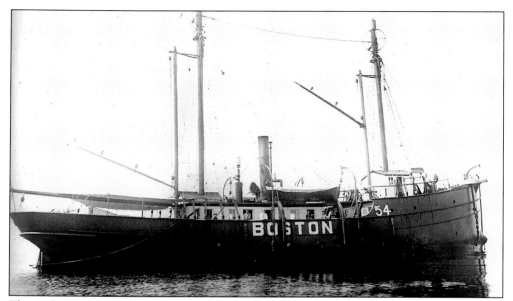

The Light Vessel LV54 *Boston*, which marked the approach to Boston Harbor and directed vessels either to Presidents' or Nantasket Roads' shipping channels, was stationed about eight miles off of the Cohasset shore and six miles east of Boston Light. Its powerful fog horn could be heard clearly by Cohasset homeowners, and on a clear day, its bright red hull could be seen. LV54 was on active duty from 1894 to 1940 and from 1943 to 1946. In 1974, the lightship station was replaced by a large navigational buoy.

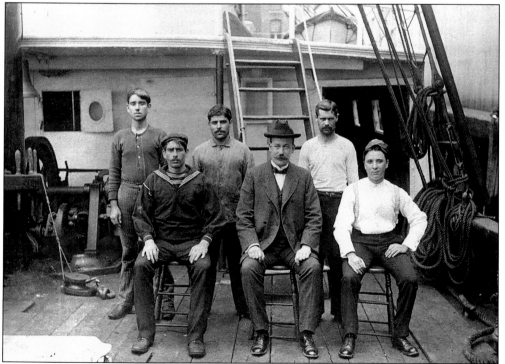

The crew of LV54, *c.* 1900, endured endless hours of boredom and isolation in addition to the ever-present risk of being rammed by passing ships.

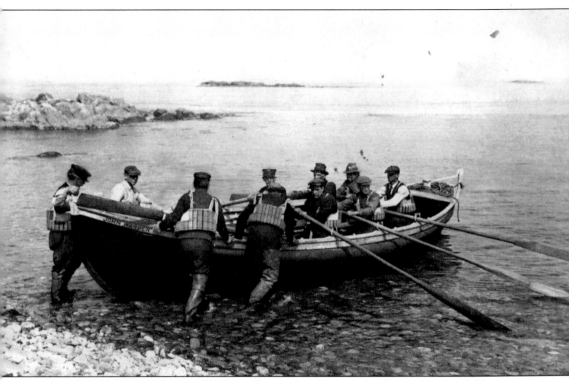

In 1807, the Massachusetts Humane Society established the first volunteer lifeboat station in America at Whitehead, Cohasset Harbor. The station was later moved to Pleasant Beach, near the causeway north of Sandy Beach. In this 1924 photograph, the Cohasset crew of the lifeboat *John Warren* are Capt. Frank Salvador, Andrew Petersen, Frank Leale, Antoine Figueiredo, Frank Martin Jr., Alfred Silvia, Abraham Antoine, Manuel Salvador, Charles Jason, and Joseph Silvia.

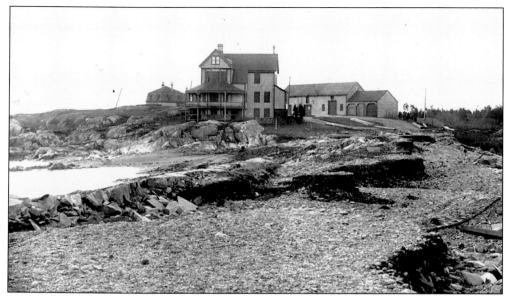

The Great Gale, or Portland Gale, of November 1898, a classic nor'easter, struck New England with heavy snow, strong winds, and high seas that sank many large vessels and left coastal areas strewn with wreckage. This view, looking southeast along the Atlantic Avenue causeway, shows the damaged road and buildings and large timbers washed ashore.

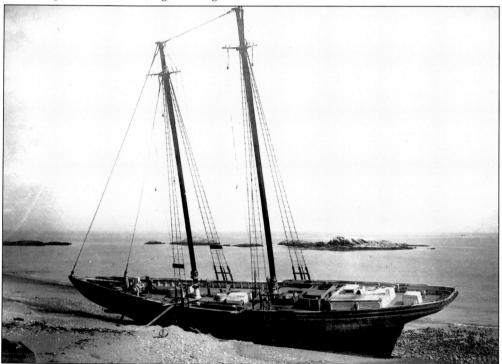

The Boston fishing schooner *Juniata* was driven ashore near Brush Island during the Great Gale. Missing the numerous offshore ledges that would have immediately destroyed the vessel, she landed a short distance south of Sandy Beach with relatively little damage. *Juniata* was later pulled off the shore to sail again.

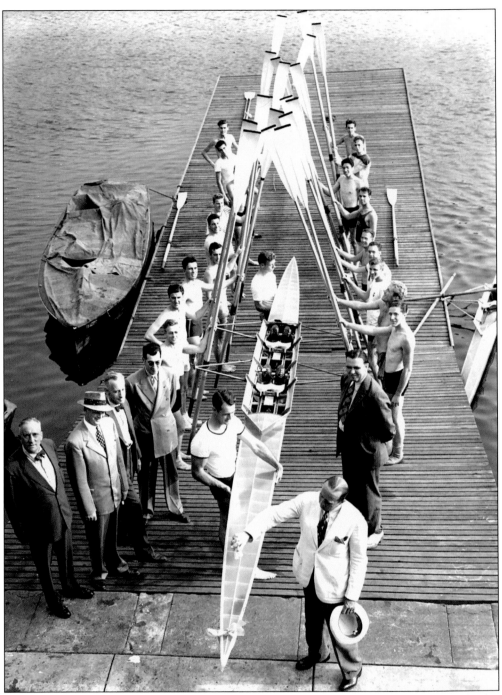

In 1938, Francis W. Hagerty purchased W. H. Davy & Sons (established 1870), a Cambridge rowing shell manufacturer, and moved the company to the end of Parker Avenue. Hagerty's shells of bonded plywood were strong and light and widely used at preparatory schools and colleges such as Browne & Nichols, Groton, Columbia, Dartmouth, and Harvard.

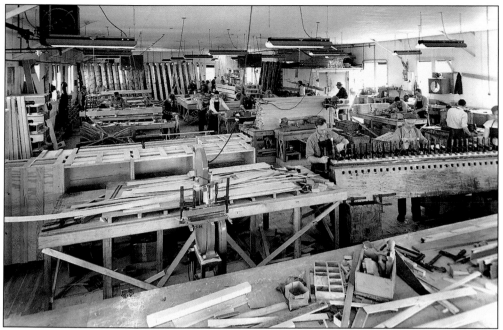

During World War II, the Hagerty Company specialized in constructing radar masts and reflectors for the armed forces. After the war, the company built sailboats and skiffs of plywood and the popular International 110 racing boat. They also produced the *Sea Shell*, an eight-foot plywood pram that could be purchased as a mail-order kit.

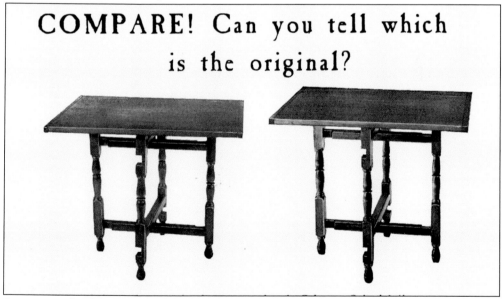

COMPARE! Can you tell which is the original?

An outgrowth of their successful boat kits and their post-war production of fine contemporary furniture, Hagerty's Cohasset Colonials was founded in 1949 to manufacture replica Colonial furniture kits. Each piece was a reproduction of a museum original or one from a private collection. In 1993, the Hagerty property was sold to the town and the company moved to Hingham. After most of the buildings were razed, Mariners Park was created. The boathouse has been restored by the Cohasset Maritime Institute.

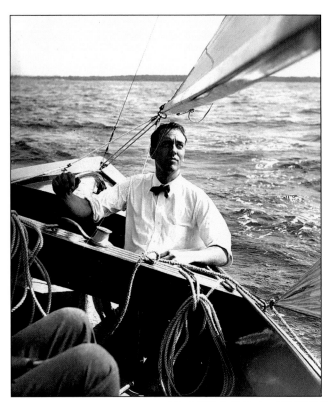

Francis Willard Hagerty (1914–1977) studied naval architecture and marine engineering at M.I.T. As a boy, he rowed on the Charles River and built rowboats and mossing dories on the South Shore and sold them locally. Hagerty's idea for the 1983 Captain's Walk, which showcases ten historic sites at the harbor, exemplifies his strong interest in Cohasset history.

Designed by C. Ray Hunt and built by the Hagerty Company, the prototype 310 Class racing sloop *Minot Light* was moored in the harbor for some years when sailboat racing resumed after World War II. The 310 was an experimental design, an enlarged International 210 Class, fast, sleek, and powerful. This was the only 310 that was built, and the hull No. 1 appears on its mainsail.

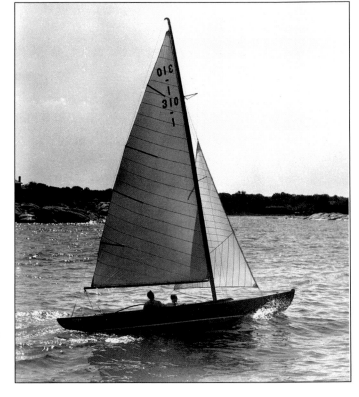

Five

SUMMER COLONY

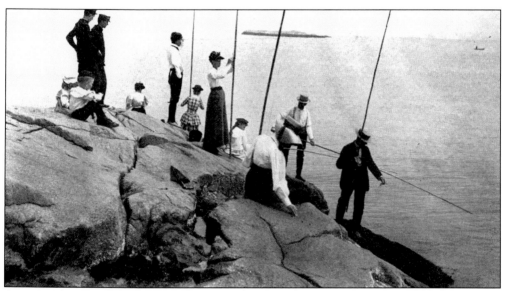

Attracted by Cohasset's cool ocean breezes and rockbound shore, families escaping the heat of the city built elaborate "cottages," or mansions, on large estates along Jerusalem Road during the late 19th and early 20th centuries. Fishing, swimming, gunning, boating, motoring, and riding were among their favorite pastimes. In turn, this summer colony provided many a Cohasset family with livelihoods at a time when the fishing and shipbuilding industries were in decline. By 1917, several associations of civic-minded citizens began buying large tracts of land from these estate owners for the public benefit, including Sandy Beach and Whitney Woods.

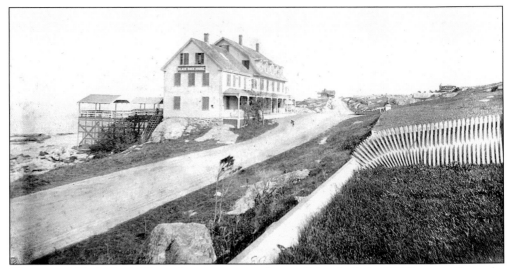

The second Black Rock House (an expansion of a small inn built in 1757) was built in the mid-19th century on Jerusalem Road and catered mainly to a genteel summer clientele. To improve the view for summer residents, however, the hotel was demolished in 1903.

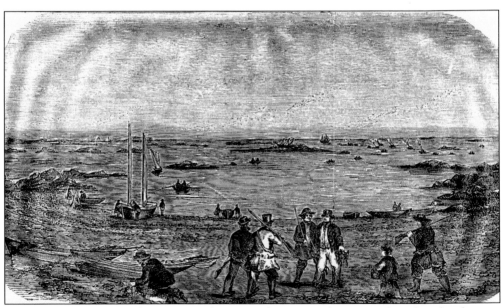

Taken from an 1851 wood engraving, this scene shows coot shooters gathered at the shore to hunt the migratory fowl. A number of summer residents who later built homes here originally came for these annual activities in the fall. Coot shooting still goes on today but under much more stringent regulations regarding the number of birds that can be taken.

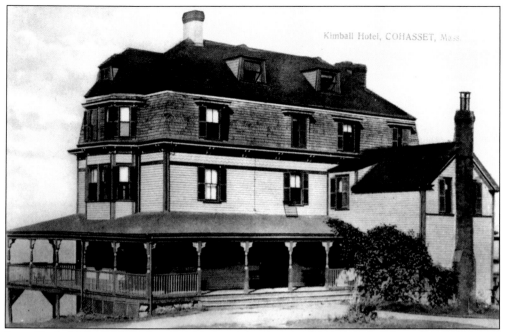

Peter Kimball's hotel on Atlantic Avenue at Pleasant Beach was known for its fine dining. The hotel was destroyed by fire in 1881 and replaced by another hotel that flourished until 1909, when it too was severely damaged by fire. Among the prominent visitors was Thomas A. Watson, assistant to Alexander Graham Bell, who later married Kimball's daughter Lizzie in 1882.

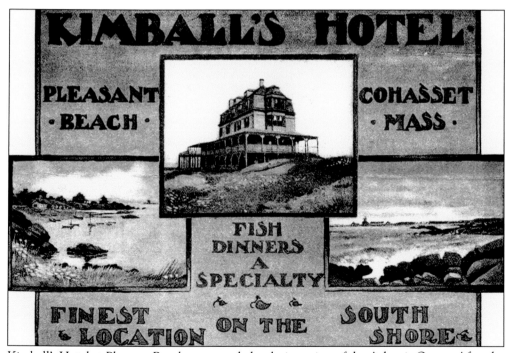

Kimball's Hotel at Pleasant Beach commanded a glorious view of the Atlantic Ocean. After the 1909 fire, he moved his business to the harbor.

This view of Black Rock Beach near Jerusalem Road dates from 1898 and shows a line of summer cottages. As a reporter for the *New York World* noted at the time, "You drive around among the rocks along a fine road, and are surprised at every turn . . . one can find as near an approach to Paradise as exists on earth."

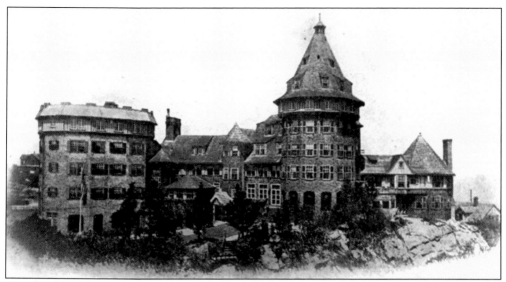

The third and last of the Black Rock House hotels was built in 1904 by Sarah Smith. In a golden era for shoreline hotels and rooming houses, it was among the most prestigious and provided luxurious accommodations. With the onset of World War II, business declined, and by the 1960s, only the Ship's Bar was still popular. Declared a fire hazard, the hotel was demolished in 1968.

Edward and Isaphene (Moore) Wheelwright owned a summer estate off of Jerusalem Road. Public-spirited citizens, the two, along with Edward's brother Henry, gave the town an 80-acre wooded preserve in 1916. Wheelwright Park, with entrances on Forest Avenue and North Main Street, contained walkways, skating ponds, and fireplaces for recreational use. The park is still popular, and over the years has provided space for camps for both Girl Scouts and Boy Scouts.

Two ladies perch on the rocks at oceanside, Jerusalem Road, in the 1880s.

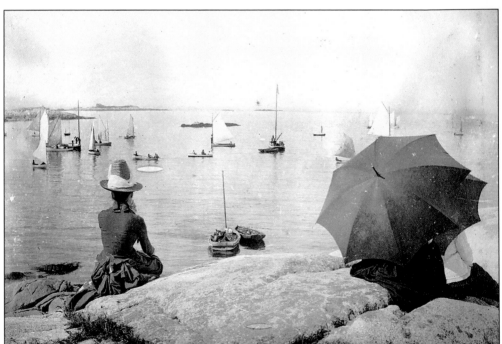

This tranquil scene at Sandy Cove from the 1890s shows a stylishly attired onlooker watching a flotilla of small sailboats getting under way for a leisurely weekend sail. Two other spectators more cautiously shield themselves from the midday sun beneath umbrellas.

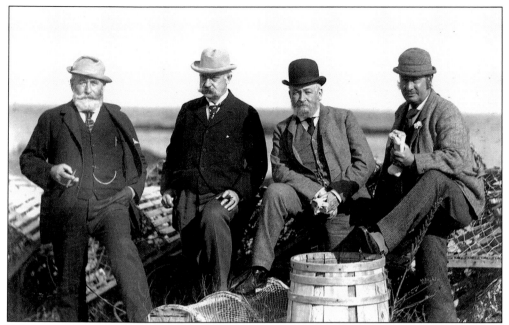

Relaxing at the shore and dressed for the occasion are, from left to right, the following: George Newhall, ? Gregerson, George Sears, and Matthew Luce. Lobster traps and a single wooden barrel form the setting, with the ocean just beyond.

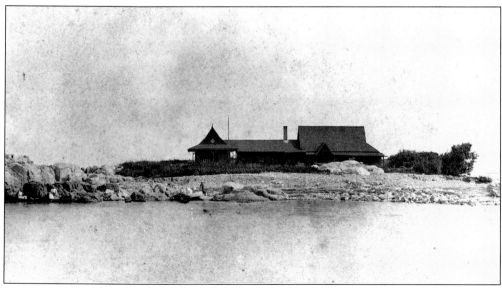

Just east of Sandy Beach, Brush Island today is the nesting ground for large numbers of sea gulls. The island was once the site of the Chinese House, a cottage belonging to Edward Cunningham, whose summer estate was nearby. The Chinese House supposedly was destroyed in a fire started by bootleggers during Prohibition. Traces of a stone foundation can still be found by those adventurous enough to explore the area.

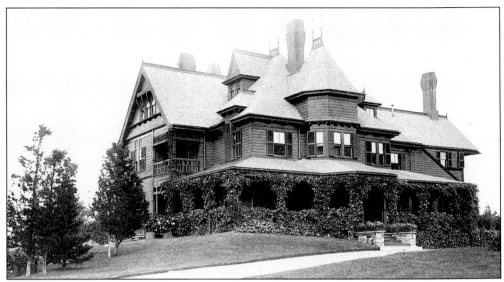

Boston banker Henry M. Whitney owned one of Cohasset's largest summer estates, a Victorian house that included a golf course and horse ring. In 1917, the Whitney Woods Association, formed after his death and the disposal of his estate, preserved 640 acres, which they conveyed to the Trustees of Public Reservations in 1933. Whitney, with fellow summer residents Grenville Braman, Henry Hyde, and Asa Potter, also created the West End Land Company to develop the recently filled-in Back Bay, Boston.

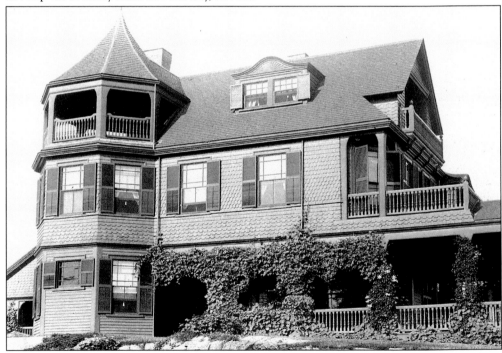

Marquis Fayette Dickinson was a summer resident in 1890, when this photograph was taken. His estate at 738 Jerusalem Road was known as "Apple Knoll." Dickinson was a member of the Boston law firm of Hyde, Dickinson, and Howe, and counsel for the West End Street Railway and Metropolitan Steamship Company.

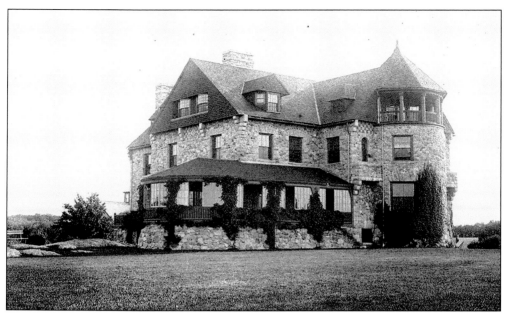

In 1886, Grenville Braman built this grand mansion of stone found on the premises, at a cost of $25,000. Known today as Stoneleigh, "The Pool," as the "cottage" was called, was designed by Boston architect William Ralph Emerson. The estate at 478 Jerusalem Road comprised 100 acres and included a stable, casino, and deer park.

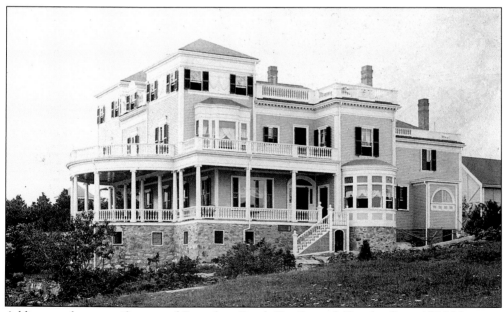

Adding to the magnificence of Jerusalem Road, Dr. Samuel Kneeland's c. 1876 Victorian mansion at 339 Jerusalem Road was called "Ahahden" after one of the sons of the Sachem Chickatawbut of the Massachusetts tribe. The second owner, Samuel Spaulding, was president of the Buffalo Street Railway. In 1947, the Sisters of St. Joseph purchased the estate.

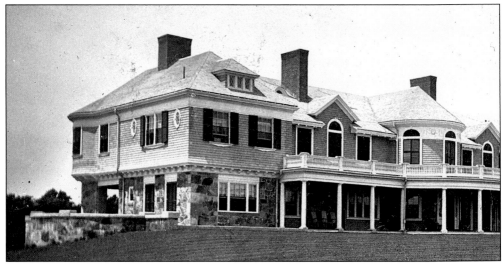

The Ridges on Jerusalem Road, built by Albert Bigelow in 1870, overlooked Little Harbor and had gardens designed by Frederick Law Olmsted. In the 1920s, Edward L. Logan purchased the estate and its extensive grounds. During the years that Polly and Edward F. Logan lived in the 40-room mansion, beginning in the 1950s, they hosted numerous charitable and social events. Deemed a white elephant in 1975, the house was demolished just before the era of condominiums began.

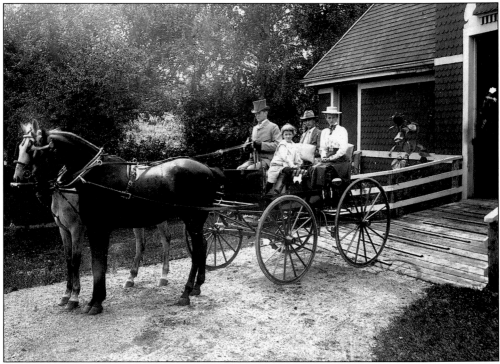

In this photograph, taken in August 1898, Joseph S. Bigelow's family sets off for a ride in their carriage driven by coachman Alexander Hillis. Their estate was located on Snow Place, today's Black Horse Lane. Bigelow was the first part-time resident to hold elective office, serving 12 years as selectman and 15 years on the school committee.

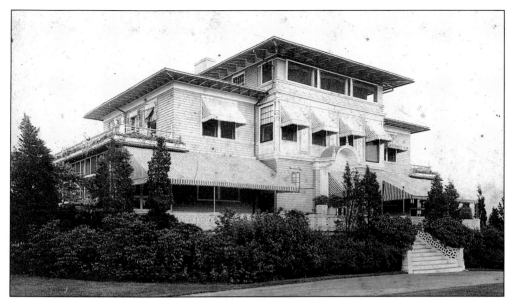

Horticulturalist, lawyer, and entrepreneur Albert C. Burrage built this residence c. 1900 on Nichols Road and called it the "Caravels," after a Spanish sailing vessel that was wrecked on a nearby beach. The estate became better known for its subsequent owner, Cyrus H. McCormick Jr., son of the inventor, who purchased it in 1915. Most of Cohasset would turn out for the family's annual June 30 arrival from Chicago, which required four railroad cars for luggage, livestock, and a staff of 60. By the 1950s, the Caravels had become 11 apartments, which in 1987 were converted to 6 luxury condominiums.

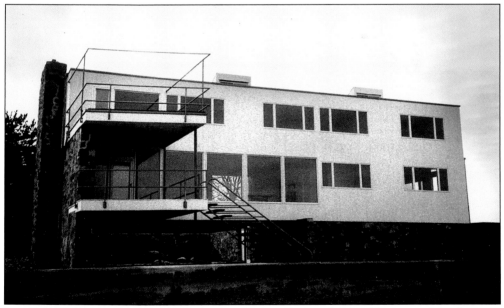

In 1938, Walter Gropius, world-famous Bauhaus architect, designed his second residence in America for Josephine Hagerty at 357 Atlantic Avenue, next to Sandy Beach. Mrs. Hagerty's son John, who had taken courses with Gropius at the Harvard School of Design, was clerk of the project. Listed in the National Register of Historic Places since 1997, the Hagerty House is a fine example of the International Style.

A group of summer residents pose for their picture at the beach.

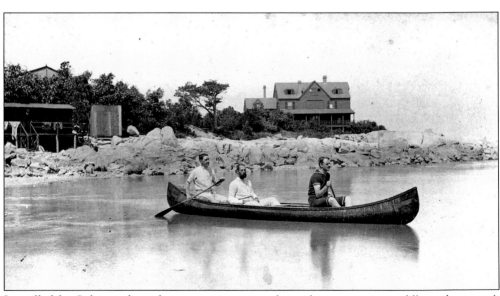

Just off of the Cohasset shore three canoeists enjoy a leisurely summertime paddle in the ocean's placid waters. Only Frank Manning, at the stern, has been identified.

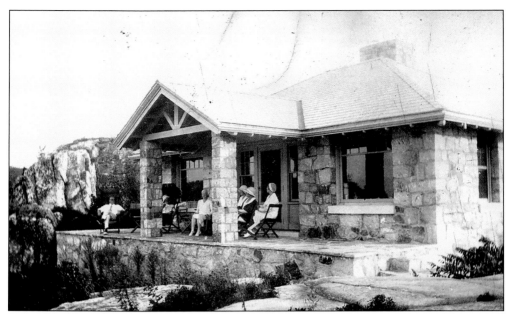

Isolated on Rice Island in the middle of Little Harbor, Charles Gammons's Camp, with its small cottage built of locally quarried granite, was a popular place for informal social gatherings.

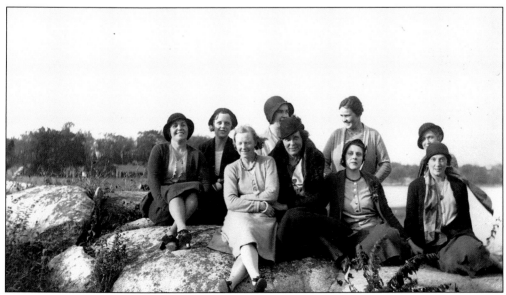

The camp built by Charles Gammons still exists. Here a small group gathers on the rocks. Sarah Gammons is pictured in the front row on the left-hand side of this c. 1925 photograph.

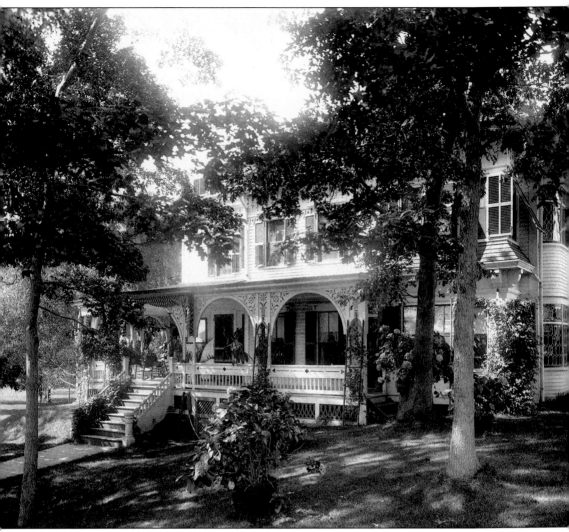

Clarence W. Barron's Victorian mansion, The Oaks, at 49 Margin Street was located on the site of the former shipyard. Richard Bourne, involved in the building of the second Minot's Ledge Light, had built the house, and the tragedian Lawrence Barrett had enlarged it in the 1870s and called it "Marie Villa." Barron owned the estate from *c.* 1898 until his death in 1928.

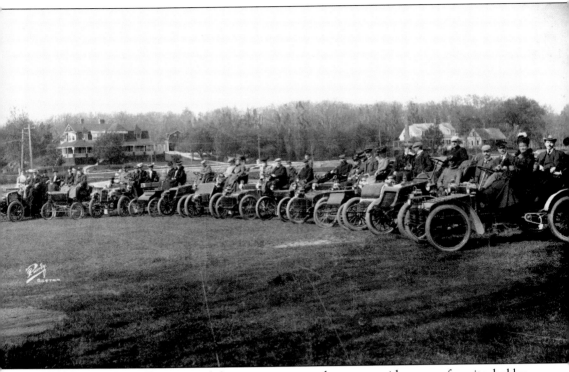

In the early days of the automobile, touring across the countryside was a favorite hobby of wealthy automobile owners. Here the Glidden Tour of 1905, both a social event and a motoring contest that allowed manufacturers to promote their newest models, meets on the side lawn of The Oaks. For many who lived along the route, this tour was their first look at a horseless carriage.

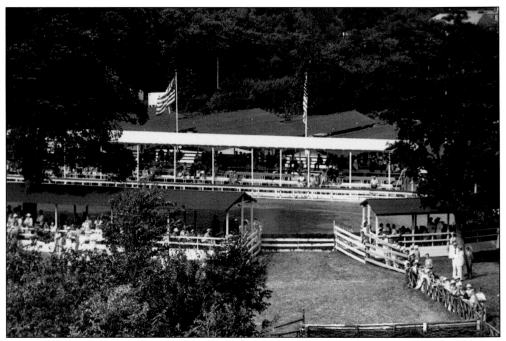

From 1925 to 1939, the Cohasset Horse Show was an annual August event that drew accomplished equestrians and affluent spectators from around the country. Several Cohasset families maintained large stables and were active in the show, until changing economics ended this popular event. In its heyday, the show attained a national status not awarded to other local shows. On this site, the South Shore Music Circus opened with *Show Boat* in June 1951.

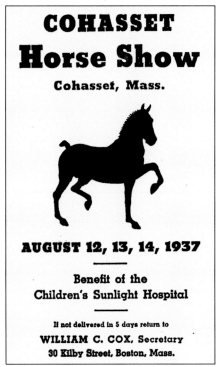

Proceeds from the 1937 Cohasset Horse Show were given to the Children's Sunlight Hospital in Scituate.

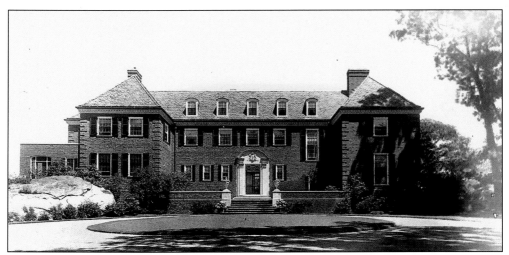

Built by Hugh Bancroft in 1929 for his daughter, Jessie B. Cox, this brick mansion replaced The Oaks. In her 55-room home with its nine acres of extensive landscaping, Jessie hosted fabulous parties for charitable and political organizations, including a large reception for Pat Nixon, her daughter Tricia, and David Eisenhower during the 1968 presidential campaign.

Jessie Bancroft Cox (1908–1982) was one of the wealthiest women in America with her inheritance from her maternal grandfather, Clarence W. Barron, founder of *Barron's Financial Weekly*, owner of Dow Jones and Company, and publisher of the *Wall Street Journal*. Jessie and William Cox's generosity to the town included the donations of Bassing Beach to the Cohasset Conservation Trust and the Bates Ship Chandlery to the historical society and the funding of the restoration of the Minot's Ledge Light construction site at Government Island.

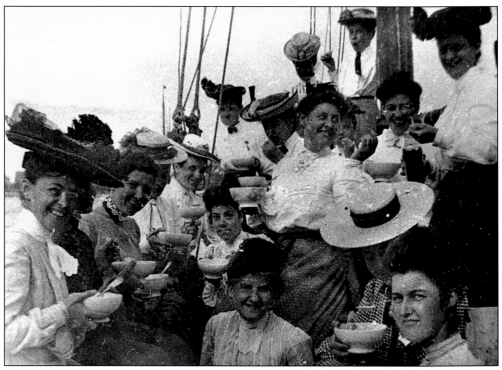

In classic summer colony fashion, this yachting party enjoys the pleasures of a day at leisure.

Hammond M. Whitney, who summered on Nichols Road, sports a matching madras tie and hat band during a day sail off the Cohasset shores.

Six

THOSE WHO CAME BEFORE US

People have been drawn to Cohasset's scenic beauty and small-town atmosphere since its beginnings. In turn, they have enriched our community life, organizing a rich variety of social, educational, and benevolent associations. Individuals also have shaped our sense of Cohasset's character. Gen. Zealous Tower and Squire Aaron Pratt, descendants of early settlers, and Carlo Conte and Joseph M. Silvia, more recent residents, represent but a few of those who have called Cohasset home.

Maria Valine, at the left, Adelaide Monteiro, at the right, and an unidentified friend enjoy Cohasset's summer weather. The Valines and Monteiros were among the Azorean families who worked their way across the Atlantic in ships, entering the United States at the Port of Cohasset. Their immigration papers may have been processed at the custom house at the corner of Summer and Border Streets.

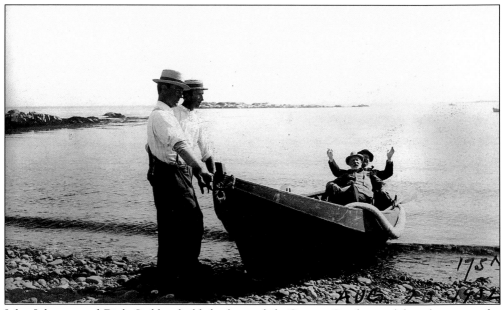

John Johnson and Dick Caddon hold the boat while George Crocker and friend wave to the photographer on August 20, 1902.

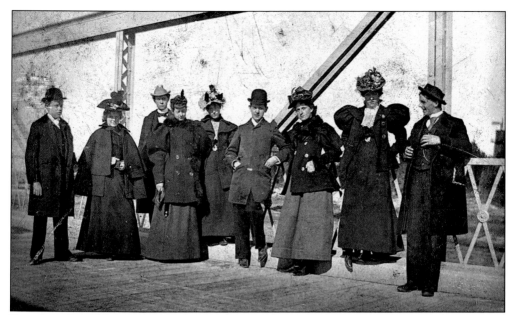

Friends and neighbors stand on Cunningham Bridge at the entrance to Little Harbor. Perhaps they strolled down Beach Street on this brisk fall afternoon, much like residents do today. Walking attire, however, has changed since this photograph was taken *c.* 1900. The group includes, from left to right, Paul Bates, Henrietta Bates Lapworth, Eugene Small, Bessie Tower, Velma Browne Bates, Burgess Tower, Ruth Mealy, Nellie Browne Ritchie, and Samuel Bates.

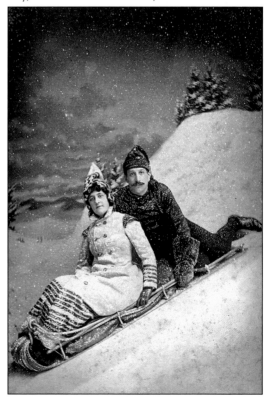

Charles and Margaret Tower Haven of North Main Street enjoy an imaginary toboggan run down a simulated hill in a fantasy snowstorm. This studio portrait was taken by Worden, photographers at 48 Winter Street in Boston.

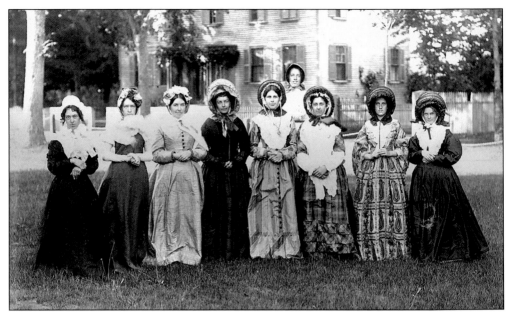

On July 7, 1898, these club women dressed up in period costume for an afternoon pageant. This group may be the forerunners of Cohasset's first women's club, established in 1927.

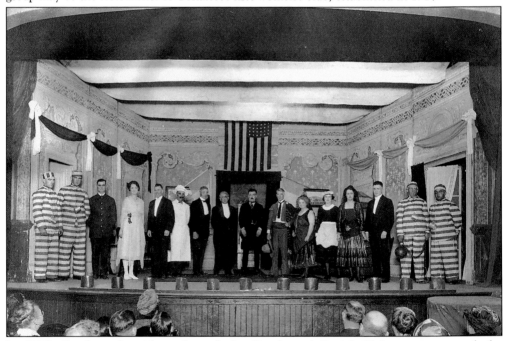

In 1909, Beechwood residents formed the Beechwood Social Club, soon renamed the Beechwood Improvement Association (BIA), for "cultivating fraternal relations among the members, to encourage every social, moral and intellectual influence, for the improvement of our community. . . ." In their building, at 502 Beechwood Street, they engaged in a variety of activities, including basketball games, Grange meetings, square dances, political rallies, dancing lessons, Saturday afternoon children's movies, plays, and minstrel shows. Due to declining membership, the BIA Hall was sold in 1978 and converted to a residence.

The Cohasset Garden Club was founded in 1925 "to aid in the protection of native plants and birds . . . and to encourage civic planting." The following summer, the club held its first flower show at town hall, where Mrs. Eugene F. Ladd, president, won first prize for her reproduction of the Miles Standish house and garden, which became the club's logo. During World War II, members donated and staffed a mobile canteen for the local Red Cross and crafted Christmas wreaths for servicemen. The club's conservation and beautification efforts in town continue today. (Courtesy Cohasset Garden Club.)

The Literary Club, formed in 1890, was active until the beginning of World War I. Originally, club meetings were held twice monthly, October through April, with Shaw's *New History of English Literature* serving as the initial subject of study. By 1916, members were studying and presenting papers on topics such as "Changes in the Methods of Warfare," "The European Situation," and "How South Americans Regard the United States."

PROGRAM.

OCTOBER 8.
SOCIAL ENTERTAINMENT.
COMMITTEE.
Miss Marion G. Pratt,
Miss Mary P. Tower, Mr. Edward F. Ripley.

OCTOBER 22.
FAVORITE SELECTIONS.

NOVEMBER 5.
LONGFELLOW.
Miss Susannah L. Stoddard,
Miss Martha J. Bates, Miss Lizzie T. Nichols,
Dr. Oliver H. Howe, Mr. E. Pomeroy Collier.

NOVEMBER 19.
MUSICAL COMPOSERS AND MUSICAL ARTISTS.
Mr. George W. Collier,
Mrs. George W. Collier, Miss Harriet J. Nichols,
Miss Marion G. Pratt, Miss Elizabeth C. Bates.

DECEMBER 3.
LES MISERABLES.
Mr. C. Frank Jacobs,
Mrs. E. Victor Bigelow, Mrs. Oliver H. Howe,
Miss Lilla L. Collier, Miss Martha P. Bates.

DECEMBER 17.
AMERICAN HUMORISTS.
Mr. E. Herbert Towle,
Miss Lizzie T. Nichols, Miss Grace H. Merriam,
Mr. Edward Nichols, Mr. E. Pomeroy Collier.

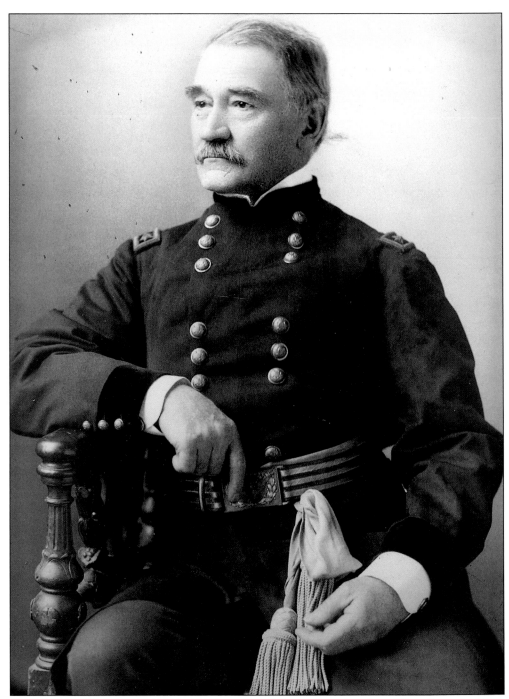

Gen. Zealous Bates Tower (1819–1900) graduated first in his class from West Point in 1841, served in the Mexican and Civil Wars, and was severely wounded at the Battle of Manassas Junction in 1862. Upon his recovery, he became superintendent at West Point before returning to active duty. In the battle at Groveton, Virginia, he was brevetted to brigadier general for meritorious service. He later served in the Army Corps of Engineers until retiring to his home at 74 Beach Street in 1879.

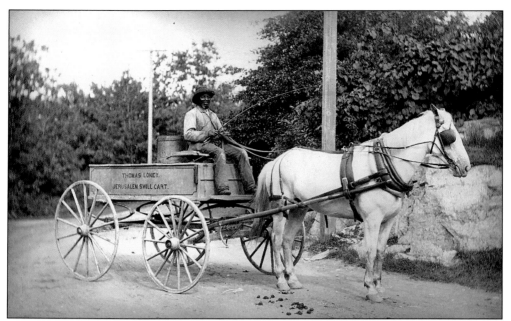

Thomas Loney (b. 1833) was born a slave in Millenbeck, Virginia. After escaping in 1861, he served four years in the Union navy. After the war, ship owner Loring Bates brought Loney to Cohasset, where he lived on Pleasant Street. Loney operated a piggery in Howe's Woods and collected swill, which he sold to local swine farms. His "honey wagon," named the Jerusalem Swill Cart, was a familiar sight on Cohasset roads.

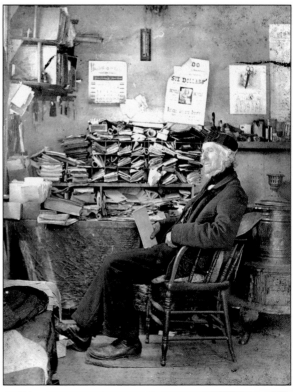

Squire Aaron Pratt (1823–1914), justice of the peace, assistant collector of internal revenue, selectman, attorney, and mercantile correspondent, also owned large tracts of farmland in Beechwood that he rented to others. He often gave parcels to worthy recipients, including the Beechwood Improvement Association. It was said of Aaron Pratt that he was among the few men of "sterling characteristics, including strict integrity . . . who value good citizenship beyond riches." At his office in Beechwood, Squire Pratt gave legal advice to those who stopped in—frequently free of charge.

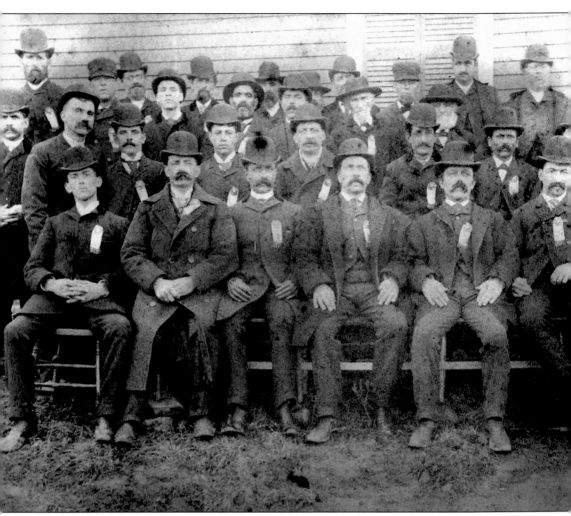

The Minot's Ledge Portuguese Benevolent Society of Cohasset was founded by Capt. Manuel Enos, Manuel Valine, John Grassie, John Silver, George Jason, Joseph Valine, Levi Cardozo, Jose Figueiredo, and George Antoine in 1895 to provide sick and death benefits for its members and families, all of Azorean descent. A social and benevolent group, the members met at Border Street until 1906, when the building was moved to 84 Summer Street. In this c. 1889 photograph, the original charter membership poses for posterity. By 1941, the society was no longer active and its building was sold.

William Franklin Thayer (1814–1916), one of Cohasset's meat merchants, served as a commissary sergeant during the Civil War. As a 44-year-old father of 13 children, he became the first man from Cohasset to volunteer for service. Upon his return from the war, Thayer operated several butcher carts and a butcher store on South Main Street.

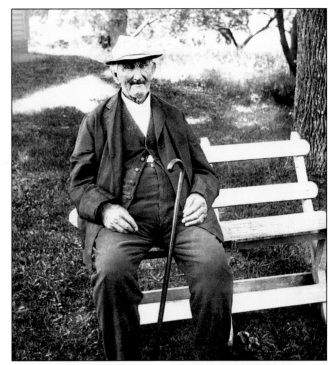

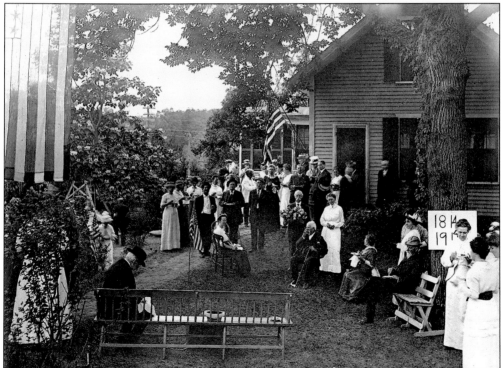

Here, on June 27, 1914, William Thayer celebrates his 100th birthday party at his daughter Emma Tyrer's home on North Main Street. Thayer was the last surviving member of the G.A.R. Post 98 in Cohasset.

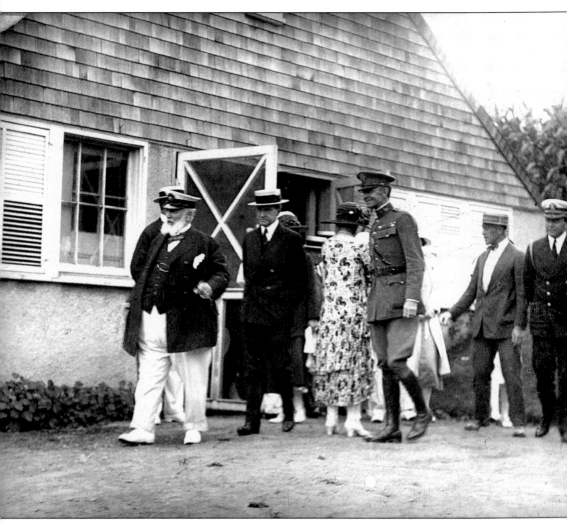

During his presidency, the taciturn Yankee Calvin Coolidge, an acquaintance of Clarence Barron, became a customer of Oaks Farm, Barron's dairy farm on Sohier Street. Barron maintained a herd of Guernsey cows, widely known for their high-quality milk. Coolidge visited Barron in the summer of 1925, and after hearing part of a carillon recital on Cohasset Common, briefly toured the farm. Here, Barron, resplendent in his yachting uniform, leads the presidential party past one of his barns.

The milking crew stands in front of the Oaks Farm dairy. Barron advertised that his certified milk was the "safest . . . to give your children," and he "delivered in Back Bay, Brookline, North and South Shores."

On October 1, 1954, the historical society presented a fashion show entitled *New Faces in Old Laces*, proceeds of which went to maintain the Captain John Wilson House and to fund a future museum (the maritime museum). The extravaganza, originally scheduled for September 3 at the South Shore Music Circus, had to be postponed for one month and held at the high school because Hurricanes Carol and Edna destroyed the tent and made roads in town impassable. The cast for the Sunday-go-to-meeting tableau included (in front) Carolyn Pratt, Nancy Tower, and Leslie Bailey; (in back) David Wadsworth, Janette and Priscilla Bailey, Dorothy Wadsworth, and Elinor Tower.

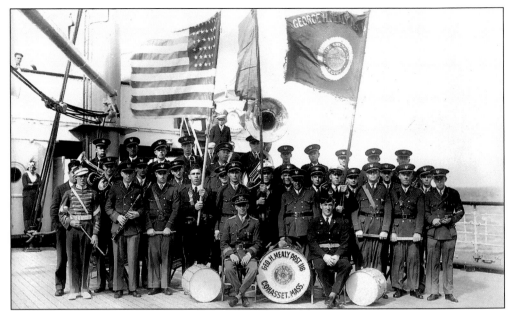

Returning veterans from World War I established American Legion Post No. 118 in 1922 and named it for Sgt. George H. Mealy, who had been killed in France. The legion quickly became active in town, organizing parades, marching competitions, and Memorial Day activities. On board the S.S. *Leviathan* in September 1931, 35 members sailed to France to visit the grave sites of Mealy and Lawrence B. Williams.

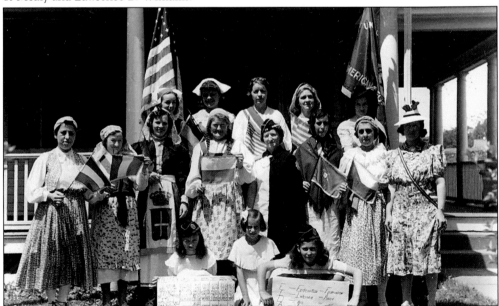

Dressed for their roles in an "Americanization" play performed during the early 1940s, members of the American Legion Auxiliary and children pose for their photograph. Kneeling in front are Catherine Rooney, Mary Mulvey, and Suzanne Roche. Standing in front are Martha Enos, Catherine Rooney, Ruth Simeone, Blanche Figueiredo, Elinor Kennedy (president), Mary Mulvey, Mary Enos, and Grace Bowser. Standing in back are Alice Curtis, Ellen Saunders, Helen Jason, Louise Sullivan, and Shirley Infusino.

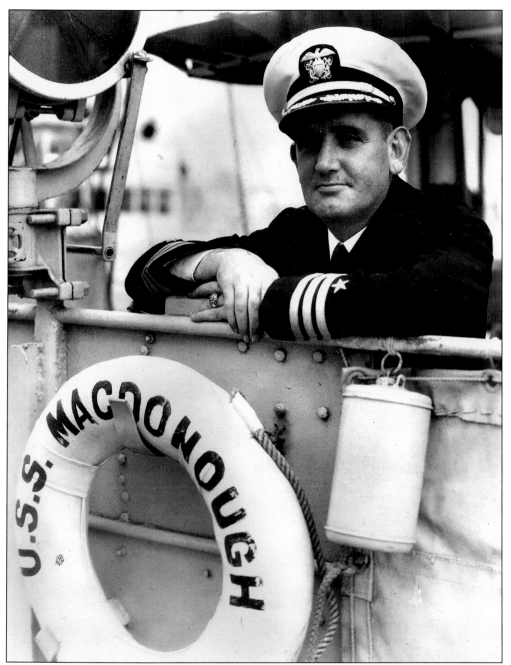

After graduating from the U.S. Naval Academy in 1916, Herbert John Grassie (1894–1973) served as lieutenant second grade in World War I, during which time he made 12 trips across the Atlantic aboard the *Tenadores* carrying troops to Europe. During World War II, he held the rank of captain and commanded the *J. Franklin Bell*, and later the battleship *Idaho*. The *Idaho* helped support the landings on the islands of Saipan, Tinian, Peleliu, Guam, Iwo Jima, and Okinawa. In 1949, Captain Grassie became rear admiral, retiring in 1954, after a naval career spanning 37 years. This photograph shows Grassie, with the rank of commander, on board the destroyer *MacDonough* shortly before World War II.

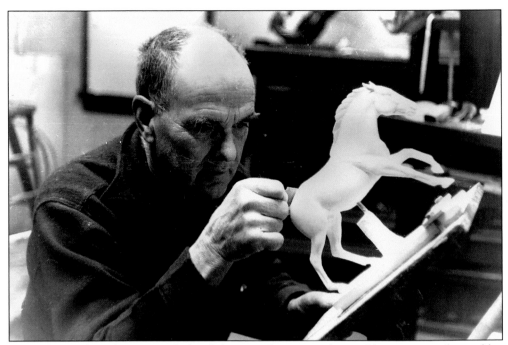

Richardson White (1904–1993) decided not to become a doctor like most members of his family. He turned instead to farming on his Jerusalem Road farm, named Holly Hill, and sculpting prize-winning bronzes. His fine sculptures reflect his lifelong love of horses. *Great Horse*, created for Boston's Tercentenary Exhibition in 1930, is part of the Boston Museum of Fine Arts' permanent collection. (Courtesy Frank White.)

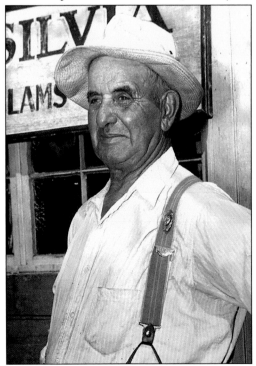

Joseph M. Silvia (1877–1969), who had long been a familiar figure at the harbor, sold his catch directly to the public at his lobster shop on Border Street. He also was a member of the Massachusetts Humane Society's Cohasset lifeboat crew. Interviewed by the *Quincy Patriot Ledger* in 1948 at age 71, he described how after 50 years, he still pulled 75 lobster pots a day.

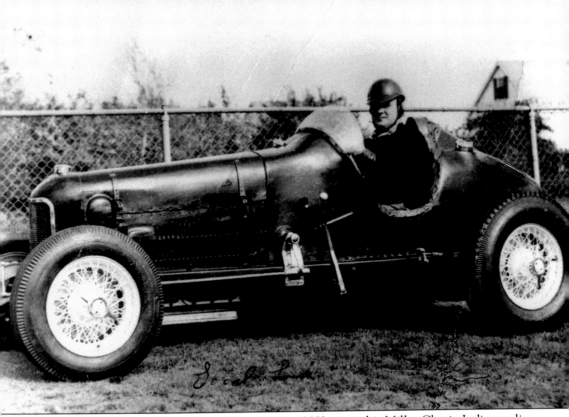

In this 1948 photograph, Joseph A. Silvia (1910–1992) sits in his Miller Classic Indianapolis Speedway car at Milliken Field. Financed in part by close friends Hugh Bancroft and Ray Remick, Joe won many races and set track records, some of which still stand. He was New England champion and nationally ranked as an AAA Indianapolis driver in 1948, the final year of his racing career, when he competed in Skowhegan, Maine, against Ted Horn, the national AAA driving champion in 1947–1948. When not racing, Joe ran an automobile repair shop on South Main Street and built race cars at his Hill Street shop. (Courtesy Rich Silvia.)

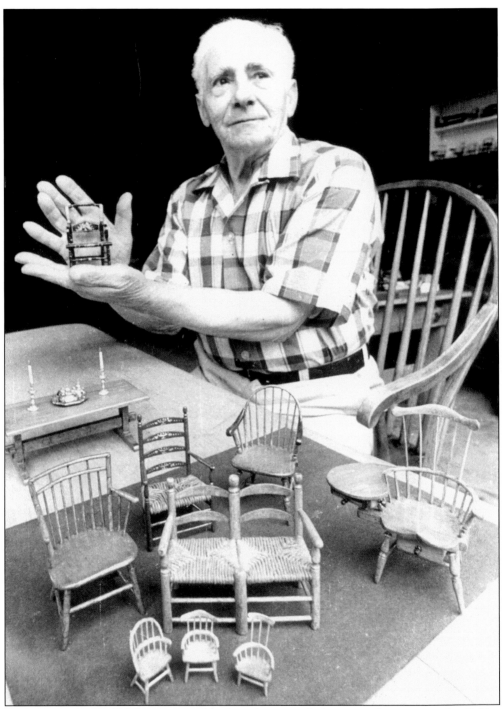

Carlo Conte (1899–1985), cabinetmaker from Amaroni, Italy, restored antiques in his Sohier Street shop for 40 years. He immigrated to the United States with his wife, Philomena, in 1923 and settled in Cohasset in 1931. During retirement, he crafted intricately carved miniature replicas of early American furniture. Today, visitors to the Cohasset Historical Society can enjoy examples of his work.

Seven

OUR THEATRICAL PAST

Cohasset's long and illustrious professional theater history began in the 1880s, when a number of prominent Broadway actors and avid yachting enthusiasts bought summer homes along the north side of Cohasset Harbor. Margin Street became known as "Actors Row," or "Brass Button Avenue" for its promenading yachtsmen in elaborate uniforms. Around the same time, amateur productions drew on local talent. Today's Cohasset Dramatic Club and the South Shore Music Circus have evolved from these rich traditions.

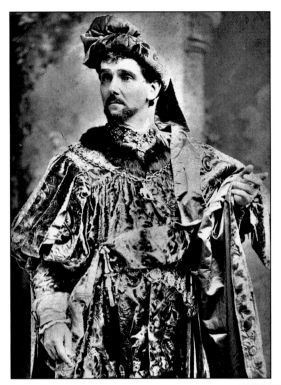

Lawrence Barrett (1838–1891), the eminent tragedian, bought a house at the cove, which was later owned by Clarence Barron. Lawrence and fellow actors would rehearse in a barn on the property. Barrett's yacht, *Lucille*, was moored in Cohasset Harbor. In 1882, Barrett appeared at the Chestnut Street Theatre in Philadelphia as Lanciotto in *Francesca da Rimini*, which was considered his greatest role.

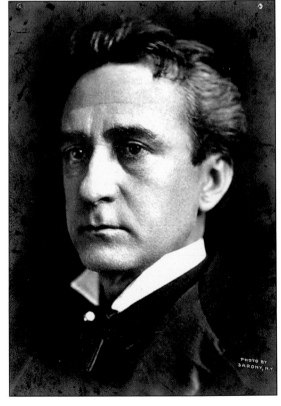

Barrett's New York business associate and acting partner, Edwin Booth, was brother of the infamous John Wilkes Booth. The year after Lincoln's assassination, Barrett played Othello to Booth's Iago, and then, with equal success, Cassius to Booth's Brutus.

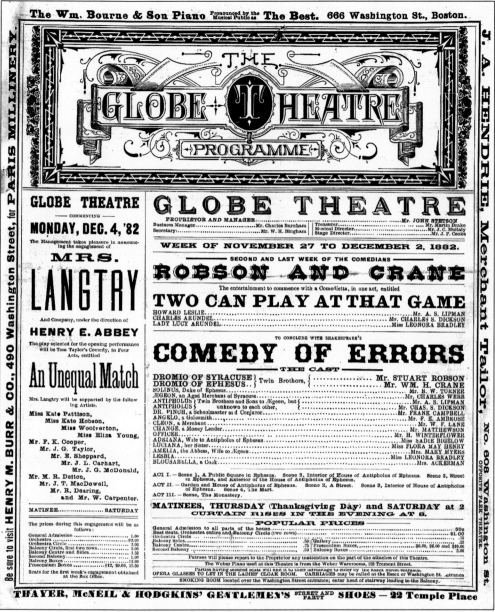

Stuart Robson (stage name for Henry W. Stuart) and William Crane also spent summers on Brass Button Avenue. Both eminent comic actors, they appeared together in Boston's Globe Theatre's 1882 production of *Comedy of Errors*. Crane was a founding member of the Cohasset Yacht Club; his yacht, *The Senator,* was named for his most famous role.

In 1889, the world-famous Hanlon Brothers brought their company, some 200 members strong, to Cohasset to recuperate and prepare the next season's productions. The Hanlons, former high-wire acrobats and gymnasts, had turned from performance to production of traveling pantomime shows after one of the six Hanlon brothers died from a fall. Their studio, carpenter shop, and warehouse were located at the corner of Ripley Road and Smith Place (later, the location of the South Shore Art Center).

This photograph of Fred Hanlon, a star of *Superba*, was taken on November 14, 1903.

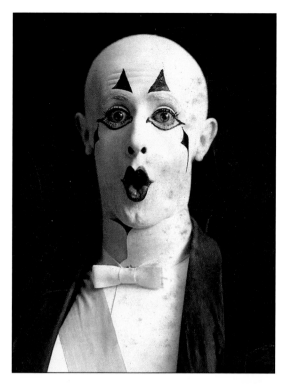

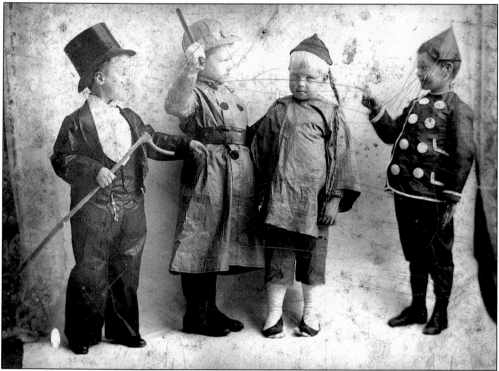

In costume for a Christmas event in 1894, the "Brownies" of the Second Congregational Church are, from left to right, Thaxter Lapham, John Bates, Philip Towle, and Minot Browne.

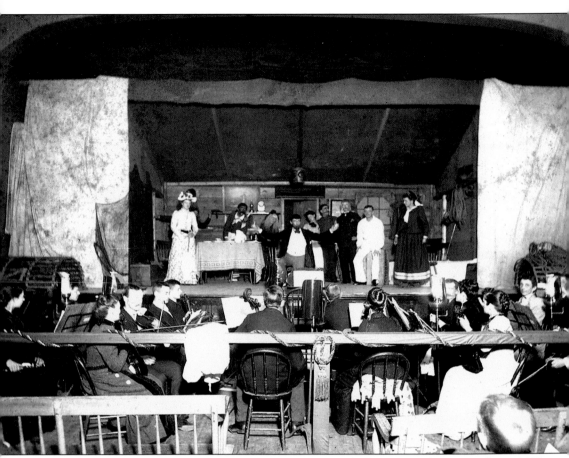

Local amateur theater also thrived in Cohasset. The town hall stage was the setting for an 1892 production of *Among the Breakers*, a drama in two acts about a lighthouse in a storm, which required artificial thunder and lightning effects.

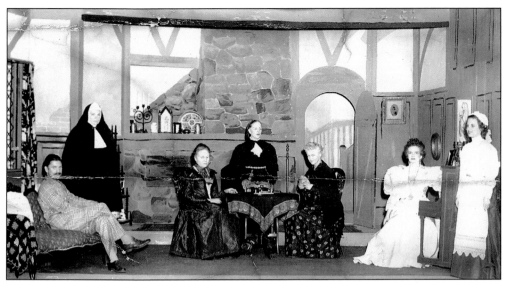

The first production of the Cohasset Dramatic Club in 1921 was a farce called *Nothing But The Truth*. Membership dues were $1.00 a year, with a minimum age of 21 for members. Junior memberships were added in 1943, which helped to keep the club going during the war years. In this photograph, the scene appears to be from the club's October 8, 1949, performance of *Ladies in Retirement*.

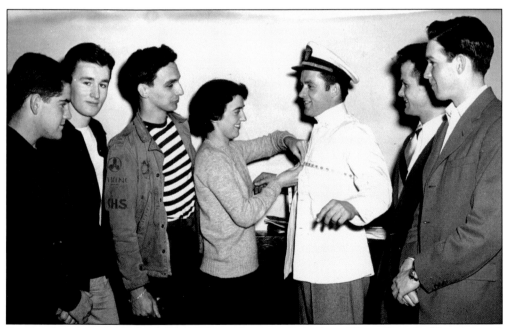

For the dramatic club's April 29, 1950, production of *My Sister Eileen*, Priscilla Hastings took chest measurements for outfitting these six Cohasset boys as Brazilian naval cadets. They are, from left to right, William Hallowell Jr., John Sweeney, Harold Coughlin, Priscilla Hastings, Donald Sweeney, Malcolm Winsor, and Frederick Thayer Jr. Today, the club is vibrant as ever, with over 300 members and three productions annually.

NEXT WEEK

Week of July 9th

EDITH BARRETT

HUMPHREY BOGART RUTH HAMMOND

AND

The South Shore Players

IN

The great New York and London Success

"THE SHINING HOUR"

By Keith Winter

EVENINGS at 8.30 P. M. MATINEE, WEDNESDAY at 2.30 P. M.

SPECIAL MATINEE, FRIDAY at 2.30

For The Benefit of

The Massachusetts Society for the Prevention of Cruelty to Children

In 1934, Alexander Dean, head of the drama department at Yale University, established the South Shore Players, the first professional summer theater in Cohasset. New plays, Broadway successes, and older productions were presented at town hall with a cast made up of unknown actors, well-known theatrical personalities, and townspeople. Humphrey Bogart played supporting roles in the first year. After returning to films in *The Petrified Forest* with Leslie Howard, his stardom was assured.

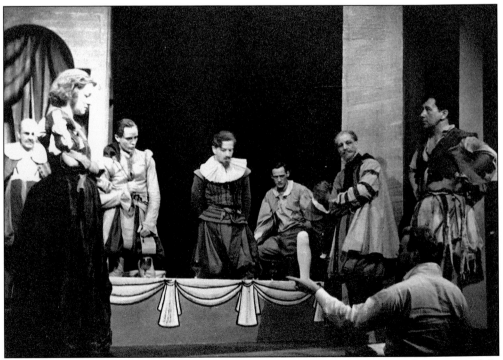

Lloyd Bridges played Lucentio in this 1936 performance of Shakespeare's *The Taming of the Shrew*. Stars of the play were Peggy Wood and Rollo Peters, while Bridges had yet to attain his future fame in the movies.

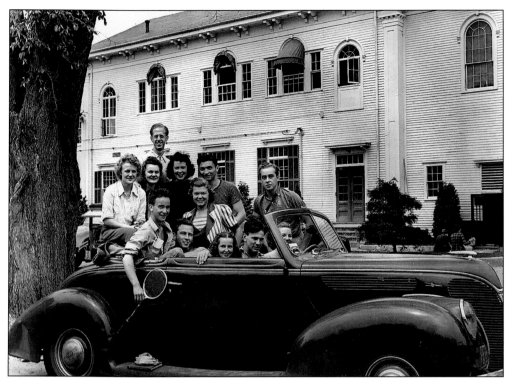

A group of South Shore Players poses for the camera in a Ford convertible after a rehearsal at town hall in 1939. Dean Jagger and Louis Calhern were among those who appeared in productions that summer.

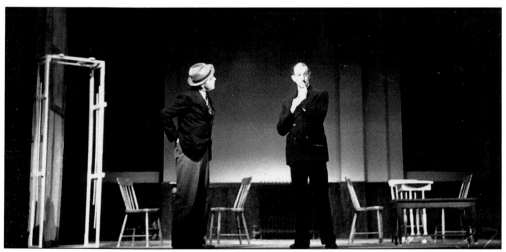

In 1939, Thornton Wilder, on the left, made his debut as the stage manager in *Our Town*, receiving rave notices from Elliot Norton in the *Boston Post*. During that season, Clifton Webb appeared in *Burlesque* and Gladys Cooper in *Spring Meeting*. The year before, Sinclair Lewis appeared for the first time on stage in a dramatization of his novel *It Can't Happen Here*.

Successor to the South Shore Players, the South Shore Music Circus opened with *Show Boat* in June 1951. By the 1970s, the Music Circus was featuring folk, rock, and country-and-western music, and even hosted the World Wrestling Federation. The South Shore Playhouse Associates, the parent company, continues to award grants to worthwhile organizations.

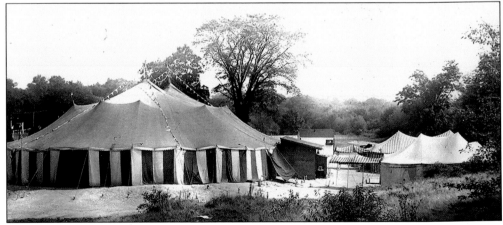

The original arena-style tent for the Music Circus had room for 800 folding canvas chairs.

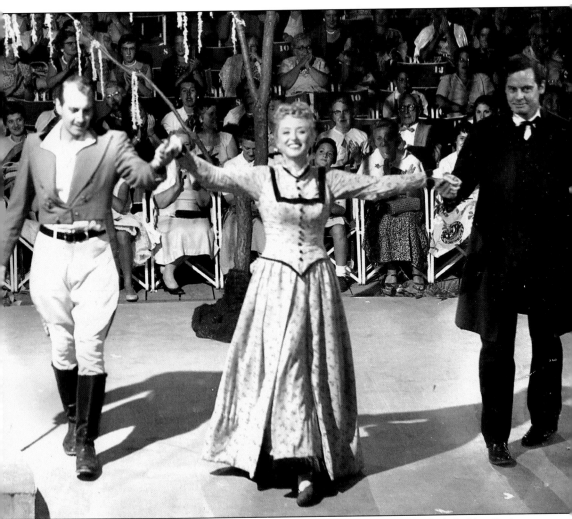

Celeste Holm, Broadway actress and movie star, appeared in a new musical, *A Sudden Spring,* from August 27 through September 1, 1956. Her film credits at this time included *The Snake Pit, All About Eve, The Tender Trap, High Society,* and *Gentleman's Agreement,* for which she received an Academy Award for best actress in a supporting role in 1947.

BIBLIOGRAPHY

Bigelow, E. Victor. *A Narrative History of the Town of Cohasset, Massachusetts*. Cohasset,
 Massachusetts: Committee on Town History, 1898. Reprinted 1970, 1981, 2002.
Cohasset Historical Commission. "Survey of the Historic Assets of the Town of Cohasset."
 Made for the Massachusetts Historical Commission, 1970–2002.
Cohasset Town Reports, 1859–1965.
Davenport, George Lyman, and Elizabeth Osgood Davenport. *Genealogies of the Families of
 Cohasset Massachusetts*. Cohasset, Massachusetts: Committee on Town History, 1909.
 Reprint 1984.
Dormitzer, Jacqueline M. *A Narrative History of the Town of Cohasset, Massachusetts,
 1950–2000*. Cohasset, Massachusetts: Town of Cohasset, 2002: vol. 3.
Leonard, Roger E. *We Protect: An Historical Account and Social Study of the Portuguese in
 Cohasset, Massachusetts*. Hooksett, New Hampshire: Cummings Printing Company, 1994.
Pratt, Burtram J. *A Narrative History of the Town of Cohasset, Massachusetts*. Cohasset,
 Massachusetts: Committee on Town History, 1956. Reprint 2002: vol. 2.
Tower, Gilbert S. Annotated historical maps of Cohasset.
Wadsworth, David H., and the Cohasset Historical Society. Various pamphlets.

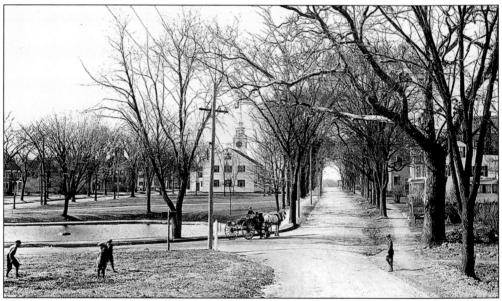

We close this book with a c. 1910 view of the Cohasset Common and Meeting House Pond,
looking north as well as backwards in time. The Cohasset Historical Society is committed to
preserving and presenting the history of Cohasset for all to enjoy. To do this well, we invite you
to share your stories and photographs with us. The society can be contacted at 781-383-1434;
106 South Main Street, P.O. Box 627, Cohasset, MA 02025.